FROM THE SUNTORY MUSEUM OF ART

AUTUMN GRASSES
AND
WATER MOTIFS IN JAPANESE ART

FROM THE SUNTORY MUSEUM OF ART

AUTUMN GRASSES
AND
WATER MOTIFS IN JAPANESE ART

JAPAN SOCIETY

From the Suntory Museum of Art—Autumn Grasses and Water: Motifs in Japanese Art is the catalogue of an exhibition shown at Japan House Gallery in the fall of 1983 and organized by Japan Society and Tokyo's Suntory Museum of Art. The exhibition and catalogue were made possible in part by a generous grant from Suntory Ltd.

Designed by Kiyoshi Kanai, New York City
Printed by Otsuka Kogei-sha, Japan
Set in Goudy & Goudy Bold by U.S. Lithograph, New York City
The text paper is 135 gm. Toku Ryōmen Art
All photographs courtesy of the Suntory Museum of Art

Manuscript processed courtesy of the Princeton University Computer Center

Editor: Alexandra Munroe

Unless otherwise noted, all poetry in catalogue section has been translated by Karen L. Brock. Some published translations have been re-phrased and the original Japanese provided.

Library of Congress Catalogue Card Number 83-081717
ISBN 0-913304-17-4

Cover Illustration: Detail of "Toiletry Case with Medallion Design" (cat. no. 9)

CONTENTS

FOREWORD

The Suntory Museum of Art was founded in 1961 by Suntory Limited with the idea of exhibiting "beauty in daily life." Consistent with this view, the Museum has been actively collecting excellent Japanese art works and presenting exhibitions ever since.

In 1978, at Japan House Gallery, we sponsored "Genre Screens From the Suntory Museum of Art." The exhibition aimed to convey the aesthetic tastes and sensitivities seen in the daily lives of the Japanese people. For the current exhibition, we have selected two motifs in traditional Japanese art, "autumn grasses" (*akikusa*) and "water" (*mizu*). We have attempted to present illustrative works displaying a variety of media and techniques. These two motifs are emblematic forms of beauty that the Japanese found in nature and reproduced in their lives. That these have been expressed in both fine and decorative arts may indicate a unique aesthetic sense. Here, "beauty in art" and "beauty in life" are a single entity.

Works in as many genres as we have been able to assemble from our Museum are presented in this exhibition, including screens, lacquerware, porcelain, and textiles. I need not add that each work is first-rate. It would give me great pleasure if an understanding of the Japanese view of art and the Japanese sense of beauty were to emerge with an inspection of this art.

My hope is that this exhibition will play a good part in the continuing cultural exchange between Japan and the United States and contribute to the mutual understanding between the two nations. Finally, I wish to express my sincere gratitude to Mr. Rand Castile, director of Japan House Gallery, and to all those who worked together to produce this exhibition.

Keizo Saji
Chairman of the Suntory Museum of Art
Chairman of the Board and President, Suntory Ltd.

PREFACE

"...the history of art is not secondarily but absolutely primarily a history of decoration. All artistic beholding is bound to certain decorative schemas or—to repeat the expression—the visible world is crystallized for the eye in certain forms. In each new crystal form, however, a new facet of the content of the world will come to light."

This important statement made by Heinrich Wolfflin in *Principles of Art History* appears in the excellent introduction by Barbara Novak to the catalogue *Next to Nature: Landscape Painting from the National Academy of Design* (National Academy of Design, New York, 1980).

The work of the Japanese artists gathered in "Autumn Grasses and Water: Motifs in Japanese Art" represents other facets of the content of the world—the Japanese show us another way to look at things. They mean to crystallize as they do, and while surfaces and techniques of Japanese art remain almost always different from those of the Western world, there is still much that is shared in subject matter and sentiment.

Further in the *Next to Nature* catalogue, Lewis Kachur quotes Albert Pinkham Ryder: "The artist should fear to become slave of detail. He should strive to express his thought and not the surface of it." This could be taken from a manual for Japanese painters of the Edo period. Kuchar also quotes Marsden Hartley on Ryder: "I still retain the vivid impression that afflicted me when I saw my first Ryder, a marine of great grandeur and sublimity, incredibly small in size, incredibly large in emotion—just a sky and a single vessel in sail across a conquering sea." This brings to mind many of the paintings of Sōtatsu, Kōrin, and the prints of Hokusai and Hiroshige.

A commonality among Japanese and Western painters is, not surprisingly, encouraged by shared latitudes and climates and the attending plant life of the regions. The snows, leaves, hills, streams, and flora we have, in large part, in common, and these perhaps join the West closer with the Japanese than linguistic and technical differences would separate us in the arts.

Our poets have delt with the same snows and grasses. When sweet William says: "Guilding pale streams with heavenly alchemy", both sides of the Pacific understand. When John Milton writes in "L'Allegro"of "summer eves by haunted stream" and speaks of "russett lawns" and "hillcocks green" the Japanese painters know, too, what Milton meant. Their poets have also said it. William Blake speaks for both the British and the Japanese when, in "Ancient Trees"—from "Songs of Experience"—he writes:

O Earth, O Earth, return!
Arise from out of the dewy grass;
Night is worn
And the morn
Rises from the slumberous mass.

Robert Burns comes close to haiku in "Open the Door to Me, Oh":

The wan moon is setting behind the white wave,
and Time is setting with me, oh!

The community of sentiment—shared by Western and Japanese—is sustained in much of the writings of Verlaine—"Chanson d'Automne"—and Rimbaud, and, even occasionally in James Joyce, who writes in *Finnegans Wake*:

"Beside the rivering waters of
hitherandthithering waters of. Night!

In the texts that follow one may see some of the parallels suggested above and, as well, the important differences in expressions. We offer this exhibition and catalogue in the hope that these "decorative schemas" will help crystallize a better understanding between the people of Japan and the people of the United States.

ACKNOWLEDGMENTS

May I first express the sincere appreciation of Japan Society to Mr. Keizo Saji, Chairman of the Suntory Museum of Art and Chairman of the Board and President, Suntory Ltd., whose enthusiasm for the exhibition has made the project a pleasure for us all. We are grateful for his guidance and support of both the exhibition and the important symposium on Japan-U.S. relations during the 1970s held simultaneously with the exhibition in New York. Mr. Masao Yuri, President of Suntory International Corp. in New York, and his associate, Mr. Eiichi Inaoka, worked tirelessly to advance the exhibition and symposium. Mr. Masami Uchida of the Suntory Museum of Art, Tokyo, made easy many difficult processes and arrangements for the exhibition and catalogue. And may I also thank the Eisei Bunko Foundation and the other private collections in Japan for their generous loans.

The good efforts of the principle essayists in the catalogue are also acknowledged. I would like to thank Professor Shuji Takashina of Tokyo University; Masakazu Yamazaki, playwright and critic; Professor Shigenobu Kimura of Osaka University; and Dr. Toyomume Minamoto, formerly of the Cultural Properties Commission. The essays were translated by the prize-winning poet Hiroaki Sato, a distinguished colleague and friend. We are grateful for his excellent work.

Karen L. Brock of Princeton University graciously consented to translate and adapt the catalogue entries. Her outstanding scholarship adds much to this work. The poetic themes, so well developed here, are Ms. Brock's contribution. All those translations of poems which appear without bibliographic source are hers', as are the transliterations of the original Japanese in many other cases. Ms. Brock is also responsible for compiling the excellent bibliography.

We would like to express our thanks to Christine Guth-Kanda for her suggestions and encouragement; and, as well, to Professors Richard Bowring and Robert Thorp of Princeton University, and Professor Nobuo Tsuji of Tokyo University.

Mr. John Wheeler, Vice President of Japan Society, effortlessly oversaw all arrangements for the symposium and assisted in many details of the project.

Mr. Kiyoshi Kanai designed the catalogue and all graphics associated with the exhibition. Mr. Gil Winter undertook the difficult coordination of the refurbishing of the Gallery and worked closely with Mr. Ashok Bhavnani, architect, and Ms. Nananne Porcher, lighting designer, on the complicated installation of an exhibition with many requirements. We are especially grateful to this excellent team for their dedication and high ability. Steven Weintraub and Andrew Collins are responsible for the design, manufacture, and installation on an individual display case basis of the prototypical humidity control system.

Japan House Gallery continues to be blessed with the leadership of Lily Auchincloss and Mr. Porter McCray, who give unsparingly of their time to every aspect of this program. We are all assisted by the outstanding Art Advisory Committee, and the names of the Committee members are listed elsewhere in this catalogue. We renew here thanks of the Society to each of these individuals.

Maryell Semal, Hisa Ota, Alexandra Munroe, and Mitsuko Maekawa continue as the spendid team for Japan House Gallery. We could do nothing without them.

Rand Castile
Director, Japan House Gallery

THE JAPANESE SENSE OF BEAUTY

Shuji Takashina

An appreciation of the Japanese sense of beauty might begin with a study of the etymology of the word "beautiful," *utusukushi*. The linguist Ōno Susumu writes in "Growth Rings of Japanese" (*Nihongo no nenrin*, Yūki Shobō, 1961) that the Japanese word *utsukushi* did not originally mean "beautiful" as it does today. In the eighth-century poetry anthology, *Man'yōshū*, the poet Yamanoue no Okura praises his wife and children in one poem as *utsukushi*, meaning they "were loved." During the Heian period (794-1185) the use of the word in "The Tale of the Bamboo Cutter" (*Taketori monogatari*) and in Sei Shōnagon's "Pillow Book" (*Makura no sōshi*) suggests that the word then conveyed affection for small, fragile things. It was only during the Muromachi period (1336-1568) that *utsukushi* assumed its current meaning.

What word, then, initially meant "beautiful?" In the Nara period (646-794) it was *kuwashi*, and in the Heian period, *kiyoshi*, according to Ōno. Of the two, *kiyoshi* is still used today more or less in its original sense: "unsoiled," "unclouded." The original meaning of *kuwashi* is retained in the word *kaguwashi*, "fragrant," but as its current meanings may suggest, originally the word also meant "detailed" or "delicate." *Kirei*, another word commonly used today to mean "beautiful" or "pretty," came into use during the Muromachi period. It, too, however, originally meant "unsoiled" and "clean." Ōno concludes that the Japanese have in their perception of beauty tended to sympathize with things that are clear, clean, pure, or small, rather than with things that represent goodness or abundance.

This etymological analysis points to two characteristics of the Japanese sense of beauty. First, as the original meaning of *utsukushi* suggests, "to be loved," the Japanese sense of beauty was based more in emotion than in intellect. Second, the Japanese idea of beauty shuns what is large, powerful, or abundant. Here, Japan contrasts with ancient Greece, where the Western concept of beauty originated.

For the ancient Greeks, beauty was an idealized value like truth or goodness, an attribute of the gods. The "Judgment of Paris," in which Hera and Athena promise the young prince power, wealth, or wisdom for selecting either as the most beautiful illustrates how beauty was equal to the other ideals. This association is also manifest in works of art. Sculptures of male bodies show gods, mythical heroes, or victors in the Olympic games, indicating that the Greek ideal of beauty was one of strength. The beauty embodied in such classical sculptures surely derives from the unstinting Greek admiration for power. In China, too, the preference appears to have been for things big. The Chinese character for beauty, *mei*, consists of parts meaning "large" and "sheep," and the character for "elegance," *li*, is composed of parts which represent a stag with magnificent antlers.

The Japanese somehow failed to see beauty in large and powerful things. In his essay, "The World of the Dexterous" ("Kiyōsha no sekai"), Kawakita Michiaki relates how once, when an exhibition of classical Japanese art was held in Rome, he was shocked to discover that even the painted screens and sliding door panels of the Momoyama period (1568-1603), the age of grandeur and splendor, looked "gentle" and "demure" in the Roman environment.

Prior to the Romantic Revolution, which altered some notions of Western aesthetics, beauty was also defined by rational approaches, such as mathematics, geometry, and dynamics. The Greeks tried to explain the beauty of the human body in terms of mathematical proportion, while during the Renaissance attempts were made to reduce beauty to geometrical principles. Belief in the same rationalist tradition was expressed by the neo-classical painter Jacques-Louis David, who observed that beauty could be realized only by making the "light of reason" its guide. His friend and theoretician Quatremère de Quincy also argued for "treating art in the same way as science."

When compared with this pre-Romantic, classical approach of the West that attempts to understand beauty by some kind of objective principle, the contrasting Japanese approach to beauty that stresses emotion and feelings becomes clear. No attempts to reduce beauty to a rationalist rule—symmetry, proportion, geometry, golden section, etc.—have been made in the history of Japanese aesthetics. Beauty has not been perceived as an intrinsic attribute of a given object, but as something that exists in the mind that perceives it.

The first manifesto of this Japanese sense of beauty appears in the opening statement of the preface to the *Kokinshū*, the first imperial anthology of native Japanese poetry compiled in the early tenth century: "Japanese poetry has its seeds in the human heart, and takes form in the countless leaves that are words." Similar sentiments were expressed in the following centuries. Fujiwara no Teika (1162-1241), the great poet and textual scholar, said in his "Monthly Notes" (*Maigetsushō*): "Make your heart the base, and be selective about diction. That is what my deceased father used to tell me." Zeami (1363-1443/45) the founder and greatest writer of and on Nō theater, proclaims in "Flower Transmission" (Fūshi kaden), "What your heart finds novel is what is interesting." Motoori Norinaga, (1730-1801), the great scholar of Japanese literature identified this aesthetic perception with the phrase *mono no aware*, "the pathos of things". Although the phrase was meant to describe Japanese poetry, it came to evoke the essence of the Japanese artistic, philosophic sensibility. "Aesthetics of feelings" has thus played an important role in the history of Japanese literature and art.

When beauty is regarded not as a specific attribute of an object, but as what is touched off in the mind

perceiving the object, the nature of the object ceases to be of primary importance. For the mind that has learned to feel beauty, any phenomenon can be beautiful. The preface to *Kokinshū* goes on to say: "We must voice the thoughts that are in our hearts, conveying them through the things we see and the things we hear." The "things we see and the things we hear" may not necessarily be perfect or impeccable. As the essayist Yoshida Kenkō (1283-1350) rhetorically asked in "Essays in Idleness" (*Tsurezuregusa*), "Why should we look at cherry flowers only at their prime, the moon only when it is cloudless?" Or as he quotes his poet friend Ton'a (1289-1372) as saying, "A thin silk cover looks attractive when it is worn at top and bottom, and a scroll roller when its mother-of-pearl has fallen off."

So here is born an awareness of beauty in things that are imperfect, missing, or ruined. In the classical aesthetics of the West, some painters, such as Nicholas Poussin or Claude Lorraine were prompted to create paintings of "idealized landscapes" on the theory that nature is imperfect and therefore should be amended. In contrast, the Japanese tendency has been to find interest and beauty in any phase of constantly changing nature.

The Japanese sense of beauty, as described here, is naturally reflected in the world of Japanese art. For example, the preference for small, delicate things, or things that are "reduced in size," is an outstanding characteristic of Japanese expression. The special appeal that things reduced in size have for Japanese sensitivity is evident in the art of garden-making, which is in essence an attempt to create an impression of "deep mountains and dark valleys" in a small plot of land. Especially in such decorative arts as lacquerware, textile dyeing, porcelain, earthenware, metalwork, and woodwork, superb techniques were developed that succeeded in depicting the most minute, elaborate details. Those who coveted and acquired such precisely, subtly-wrought objects no doubt adored the unparalleled craftsmanship congealed in them. At the same time, however, we must assume that the meticulous details conveyed a certain beauty. This admiration for details is evident not only in the decorative arts, but in the fine arts as well.

From the earliest examples of Buddhist paintings that used cut gold foil patterns (*kirikane*) to pre-modern screens and door paintings of floral and animal themes, Japanese paintings have tended to be strongly decorative. These works often show a preference for things reduced in size. Prime examples of such paintings are the genre screens of the sixteenth and seventeenth centuries depicting the manners and customs of contemporary townspeople where countless numbers of tiny people are depicted with a wealth of detail.

It is often pointed out that Japanese painting, when compared with Western painting, is flat and lacking in realistic detail. To be sure, in its disregard for the unified, three-dimensional depiction of space seen in the mastery of scientific perspective that has been refined since the Renaissance, Japanese painting is not "realistic." Indeed, it is precisely because of this that Shiba Kōkan (1747-1818) and the few other Japanese artists who became acquainted with Western painting techniques in the early nineteenth century, were astonished by the realism that could be achieved. Nevertheless, this does not mean that Japanese painters lacked the desire to observe the real world and reproduce it "realistically." They were realistic, not in spatial composition, but in the depiction of details. And this has much to do with the Japanese sensitivity that found aesthetic delight in a world whose size was small and intimate.

Along with a preference for small things or things reduced in size, a preference for things that are clear or clean is reflected in a number of artistic works. Typical of this aesthetic is the attitude that has treated with respect the unadorned wooden structures of the Ise Shrine, or the blank space in a painting.

Originally, the word *kiyora*, "cleanliness," described an unblemished, unclouded condition. It did not denote a positive state *with* something good, but a negative state *without* anything unnecessary or repugnant. Artistically, this attitude may be said to have formed the basis for an "aesthetics of denial." For the ancient people's inclination to see beauty in things clean was inherited in the attitude in later periods that found a rich, profoud beauty in the monochrome world of ink painting that rejected brilliant colors of any kind, or in Nō drama, where restraint in movement and props was carried to the extreme. This aesthetics of denial is illustrated by the famous morning-glory episode involving the unifier of Japan, Toyotomi Hideyoshi (1537-1598) and the tea master Sen no Rikyū (1520-1591). Hearing that Rikyū had cultivated a garden of morning-glories, Hideyoshi asked to see them. Rikyū complied, but when Hideyoshi arrived he found the garden stripped and empty. When led into Rikyū's tea room he saw a single morning-glory arranged in the alcove. The same aesthetic is, needless to say, related to the ideals of *wabi* and *sabi*, which exalt simplicity and restraint.

When the love of small things and the aesthetics of denial are merged, in an artistic design, specific aspects of nature are extracted and presented in exaggerated, close-up form. Typical of this technique are the pictures of flowers and grasses, ubiquitous in Japanese art. Of course in the West, too, there are many paintings focused on a variety of flowering plants. But in the West, such plants are always presented as part of the appropriate setting, as in Botticelli's *Primavera*, which gives a section of a spring field, and in many still-lifes by seventeenth-century Dutch painters, where the flowers are arranged in a vase on the table. In contrast, the Japanese pictures of flowers and grasses usually present nothing but the subject itself, and often

only a partial view devoid of natural setting. A representative masterpiece in this genre is Sakai Hōitsu's (1761-1828) pair of screens, "Summer and Autumn Grasses." Flowers and grasses are meticulously painted in the extreme foreground, but except for a suggestion of a stream in the summer screen, there is neither ground, field, nor sky, only a silver foil background. From the depiction of the flowers and grasses, one imagines that they are out-of-doors, but the painting gives no specific hint. (A similar approach to the subject of autumn grasses is seen in cat. no. 3.)

A uniform gold or silver background, incidentally, is favored by Japanese painters not only in depictions of nature, but also in genre and figure paintings. Such a flat background naturally carries with it a decorative effect, but also a tendency to simplify by discarding everything but the main subject. This should be evident in the "Dancers" (cat. no. 50) panels, where nothing indicates whether the scene is taking place indoors or outdoors. In Western genre painting, such as in seventeenth-century Holland, details of place and setting are as much a part of the painting as the main subject. If the subject is indoors, part of the wall, floor, or ceiling will be shown, and if it takes place outside, part of the town or woods will be incorporated.

The strong Japanese concern for a specific subject spawned the unique compositional teachnique of presenting only a small section of a given object. Paintings in this manner are called "broken-branch painting" (sesshi-ga). As the name suggests, a typical painting of this type may present only a branch of a plum tree, and nothing else. Or, even where some other part of the tree is shown, such as the trunk, its presentation can end abruptly with the paper edge. For example, in the "Plum Garden at Kameido" a woodblock print by Andō Hiroshige (1797-1858), only a small section of the trunk of a large plum tree is shown in the foreground. It is well known that Western painters of the nineteenth century were greatly influenced by Japanese prints. The important aspect of that influence lay in the bold, startling compositions of the "broken-branch" manner. To put it differently, the composition that presents one part of a given object in magnified form was unique to Japanese art.

In the perspective composition of the West, the painter looks at the world in front of his eyes from a fixed position and expresses in a pre-determined grid the world seen as if through a window frame. For him, what corresponds to the window frame is the space of his canvas. In Western painting, therefore, the framework of the canvas, like the painter's viewpoint, is an essential premise for effecting a unified spatial composition. In Japanese painting, which has no fixed viewpoint, the canvas is infinitely expandable, at least in principle. In reality, of course, a screen or a sliding door does set some limits, but the world depicted in one tends not to be completed in the space given but to go beyond it. When it comes to the paintings in the "broken-branch" manner, the existence of other parts of the depicted subject is assumed as a matter of fact, so that the world beyond the limited space almost becomes a part of the world captured in it. To put it somewhat differently, whereas in classical painting of the West the world depicted in the framework of a painting is expected to form a complete microcosm isolated from whatever is outside, in Japan's classical painting that is not the case. There, whatever restrictions a given space have seem weak. Actual physical limitations there certainly are, but they do not put a lid on the world outside.

The Japanese sense of space as a continuum can also be seen in endeavors other than painting. For example, in traditional architecture, no clear distinction is made between indoors and outdoors. A typical house has such parts as the "under-the-eaves" (noki-shita), the "wet-porch" (nure-en), and the "corridor crossing" (watari-rōka), that cannot be defined as inside or outside parts, but which in their amorphous way play an important role in linking the inside and outside. A similar function is observed inside the house as well. Room partitions are deliberately impermanent; two or more rooms can be simply turned into a single large space by removing the sliding doors dividing them.

The lack of sharp distinction between the space inside the building and the space outside also means the uninterrupted continuation of the human world with the natural world. Japanese people do not regard nature as an entity separate from man; instead, they have developed the view that man is part of nature, one with nature. It is no accident that flowers, grasses, birds, streams, and other manifestations of nature have been frequently taken up as subject matter in Japanese art. The importance of traveling from one place to another through mountains or across the sea (michiyuki) seen in picture scrolls and classical drama derives from the fact that it epitomized the ultimate state of man being one with the elements.

Another outstanding aspect of the Japanese sense of beauty is the integration of art works with daily life. The lavishly painted sliding doors and screens are at once art objects and furniture. Hanging scrolls in the alcove are changed frequently, appropriate to the season and the occasion, creating an aesthetic space in ordinary life. In Japan, where no true distinction is made between fine and decorative arts, artists have often been craftsmen, and the same motifs have recurred in paintings as well as craft works. In modern times, the Japanese mode of life has been extensively Westernized, and the traditional approach to art is disappearing. But as long as art works of the past remain, the traditional Japanese sense of beauty will be preserved.

LIFE IN ART AND ART IN LIFE: PICTORIAL AND DECORATIVE ASPECTS IN JAPANESE ART

Masakazu Yamazaki

One notable characteristic of Japanese art is that little clear distinction exists between pure and applied art. There is continuity between the genres of painting and sculpture and those of decorative arts.

This characteristic is not easily found in Western nor much Eastern, that is, Chinese art. Pictures on the ceramics of ancient Greece are considered today products of great applied art, but the names of their makers are hardly known. On the other hand, Polyclitus and Lysippus have left their well-documented sculptures —products of pure art—but no records suggest that they also decorated furniture and kitchenware, as was the case with great Japanese artists. Giotto, da Vinci, Ingres, Delacroix: none of these artists is known to have designed utilitarian, decorative objects.

Some Renaissance artists did have the skills of metalworking, pottery or masonry. The sculptor Donatello is said to have originally been a mason, and Luca della Robbia, who started out as a potter, came to be known as a great ceramic sculptor. Those architectural decorations were reliefs or sculptures in terracotta, likely to strike the viewer as murals or otherwise independent art works. These artists did not, in other words, include domestic utensils in their repertoire of decorative skills.

There is also the matter of aesthetic evaluation of decorative products: neither the artists nor the critics have regarded them equally as the products of pure art. Although Ghiberti and Verrocchio made ornaments and cups in gold, these pieces neither received high marks from their contemporary critics, nor have they been preserved as carefully as their sculptural works. Della Robbia's female busts have been left to us, but the vases and bowls he is likely to have made have not.

In the West, architecture has traditionally been accepted as a discipline of pure art. Indeed, some of the great Western painters and sculptors were also great architects. That utilitarian architecture was categorized as fine art while equally utilitarian decorative works, including those by outstanding artists, have been regarded as secondary, is revealing. It must reflect a philosophy that lies behind the Western view of art.

To be sure, in modern times makers of decorative pieces in the West have come to be recognized as artists. But few are known to have made tableaux and sculptures. One of the rare exceptions is Picasso, who, while showing his extraordinary talent in painting and sculpture, also worked in ceramics. Still, much of his pottery is not utilitarian, but sculptural and highly "artistic."

In China, too, there are no indications that master painters such as Ma Yuan and Hsia Kuei of the Sung dynasty (960-1268), for example, volunteered in the production of ceramic ware, otherwise one of the greatest achievements of Chinese civilization.

The tradition has been different in Japan. Eminent artists since the medieval times have designed, decorated, or produced wares for utilitarian, daily use. Also, makers of decorative pieces have been respected and remembered in history as artists. The great artistic leader of the Momoyama and early Edo periods (ca. 1575-1650), was Hon'ami Kōetsu (1558-1637). Born to a family of sword connoisseurs, he later designed and published the "Saga Books" (*Sagabon*), directed designs for lacquerware, and worked in many other traditional art forms. Tawaraya Sōtatsu (died ca. 1643), known as the foremost painter of brilliantly colored screen paintings on gold leaf background, is known to have been a fan painter, traditionally regarded as a fine art. Ogata Kōrin (1658-1716), artist of such well-known screens as "Irises" and "Red and White Plum Trees," also worked as a potter and textile designer. As ceramics, like fan-painting or lacquerware, has been traditionally regarded as a high art in Japan, many great potters such as Ogata Kenzan (1663-1743), Nonomura Ninsei (1574-1660/6), and Furuta Oribe (1544-1615) have left their mark in art history. Even today, ordinary tea bowls and other kitchenware sold in regular markets often bear the makers' seals. The swordsmith Seki no Magoroku (active ca. 1600), the textile designer Miyazaki Yūzen (18th century), and the tea master and garden designer Kobori Enshū (1579-1647) are among the many craftsmen and masters of utilitarian skills who have been acclaimed as artists.

In Japan, a work of pure or fine art often shares techniques with the applied or decorative arts. Conversely, decorative arts may comprise pictorial, representational motifs. Thus, within a single composition, the realistic and figurative may appear side by side with the stylized, abstract, and patterned. "Decorative" in this context refers to objects of simple, utilitarian form decorated with designs that are "units" or independent, interchangeable parts of a whole composition. "Pictorial" denotes an integrated composition, a subject matter with an organic unity of its own designed for a unique object. Whereas decorative tends towards abstraction, pictorial tends towards naturalistic representation. Viewed with these definitions in mind, decorative and pictorial expressions in Japanese art appear indistinguishable from one another or are often juxtaposed. The arrangement of wildflowers in the "Autumn Grasses" screen (cat. no. 3) has a striking resemblance to that of the design on the Nō robe decorated with wild carnations (cat. no. 4) in their abstract and ordered expression. Pictorial imagery also appears in works of genuine craftsmanship. For example the inkstone case with the design of "The Shrine of the Fields" (cat. no. 26) presents an ox-cart parked in a bank of autumn grasses that is as representational and pictorial as those painted in scenes from the twelfth century "Illustrated Tale of Genji" scroll. Similarly the bridge depicted on the sides of the tiered food box with hydrangea (cat. no. 43) should recall some of the

bridges in scenes from well-known screens, paintings, and wood-block prints.

A careful look at the "Plain of Musashi" screens (cat. no. 2) reveals that these paintings combine representational forms with stylized designs. The mixture of abstract and descriptive expressions is typical of Japanese paintings of the medieval and pre-modern periods. Many of the decorative screens in colors on gold leaf of the Momoyama period present considerably realistic landscapes shrouded in golden hazes. The nature of these hazes is ambiguous. On the one hand, they seem to recreate a natural phenomenon; on the other, like the backgrounds of religious paintings of the West, they seem no more than an abstract and indefinable space. A paradox is visualized in which what is pictorial becomes decorative, while at the same time what is decorative becomes pictorial.

These characteristics of Japanese art naturally embody an aesthetic or view of art essentially Japanese. In the West, "great art" has long been considered the spiritual expression of a solitary artist. Before the Medieval Age, it was thought that an "Idea," or God's spirit, came upon an artist, and that a work of art was the product of divine inspiration. Traditionally, an artist produced work through dialogue with some transcendental ideal. His expression, therefore, did not essentially mean to appeal to his fellow human beings, nor to embellish mundane existence. Secluding himself in a holy world clearly set apart from secular reality, the great artist constructed a microcosm in a work of art.

Despite changes in Western religious attitudes since the modern age, the traditional concept that art is an expression of a solitary spirit has persisted. This view is spelled out in R. G. Collingwood's excellent book, *The Principles of Art*, (Oxford University Press, 1958). It takes the position that art is the artist's attempt to explore his own self and that, therefore, applied art is not art. According to Collingwood, an artistic expression is an act in which the artist explores ambiguous and shapeless emotions within himself, and articulates them with an external corresponding form. The artist does not clearly know his own emotions before beginning to express them; only through the work process of expression does he ascertain the true nature of his emotions. At the outset understood with crude, conceptual words, emotions such as "anger," "sorrow," "joy" are gradually and precisely assimilated and then externalized with words, colors, or sounds. According to Collingwood, artistic expression is an act of self-discovery on the part of the artist, and in the sense of "making something out of nothing," art is a process of genuine creation.

In contrast, Collingwood goes on to say, applied art is defined as that which effectively conveys a message or an image conceived and designed before the artistic process begins. The very purpose of applied art is to reach an audience; it is a social rather than a solitary act. For the author, therefore, the artistic process of applied art is neither a true discovery nor a creation. Collingwood thus rejects the process and the product as secondary or ingenuine, and clearly distinguishes high craft or decorative arts from fine arts. That applied and decorative arts are meant to be used, enjoyed, and accepted by other people speaks against their creative integrity.

In Japan, however, art was traditionally regarded as a means for one to commune with others. The Japanese artist has seldom aimed to express an isolated, solitary self; rather, he has produced works in relation to other people, in specific social settings, as "entertainment." Poets, too, typically composed impromptu poems at a gathering, expecting and receiving immediate comments from fellow poets. This approach produced in time the unique poetic form of "linked verse" (*renga*) which alternates long and short lines composed by two or more poets gathered in one place. In *renga*, poetry is composed as conversation among a group of people, and its aim is to create an emotional harmony and consensus. In painting as well, an artist's final execution was often carried out in a social setting. Here, a friend or an admirer of the painter would write in the blank space of a given piece a colophon expressing praise or sympathy, thereby completing the process of painting.

In theater, the expression is consummated in front of an audience. It is notable, however, that in classical Japanese dramatic theories, attention to the audience is emphasized. According to the founder of Nō drama, Zeami (1363-1443/5), the actor is required to devise ways to please any audience, even those composed of non-connoisseurs. For Zeami the appeal and success of a performance lies in the novelty with which it is played; something that must be created each time fresh for the audience. The Japanese artist, like Collingwood, believed that an expression is a creation, and that an artistic emotion can not be presented as a fixed, predetermined concept, but has to be discovered and presented anew each time. But the Japanese artist, unlike Collingwood, believed that the discovery and the creation are not necessarily made by a solitary spirit but by people gathered in a specific social setting.

So long as an expression in Japan aimed to create not a closed microcosm for a solitary spirit, but an emotional consensus between the creator and his appreciators, the idea that works of art are isolated from society was not conceived. As long as art was expected to please other people and to engage their active participation, it essentially aimed to acquire the attributes of craft and applied art.

Indeed, many works of fine art in Japan were made in such a way that the viewer could touch, move, or

otherwise handle them. With the horizontal picture scroll the viewer rolls and unrolls the scroll himself, adjusting what he wants to see. Or take the sliding doors and screens on which many of the finest examples of Japanese painting appear. The viewer can move these around on his own. In this particular aspect, Japanese architectural decorations are quite different from most of the West. Screens and sliding doors are expected to be moved, and they change their compositions as they are moved. But Western murals and reliefs are not really expected to be freely moved about. They are essentially fixed tableaux, closed microcosms.

It is possible to say that, in Japan, paintings generally considered to be "works of fine art" were treated with no more or less respect than were *kosode* designs, the lacquer patterns on a box, or even the binding of a book as long as each could be freely handled. A work of fine art was, then, appreciated as a decorative or high craft object. It follows that in Japanese art, naturally, no decisive distinction was made between what was artistic and what was decorative.

It sould be obvious, then, why in the West architecture was traditionally regarded as a genre of fine art, but decorative arts in general were not. The buildings that were regarded as artistic works in the classic and medieval West were limited to pantheons and churches, which were in principle far removed from human, physical manipulation once erected. In addition, they were made of stone, boasted of massive solidity, and gave the impression of an utter indifference to the small, familiar tools of daily life. Japanese buildings, in comparison, were made of assembled wood pieces. However important in the history of Japanese art, traditional domestic architecture was the domain of applied art.

Certain motifs recur throughout the decorative and fine arts of Japan. Such things as "autumn grasses," "water," and "wheels," appear and reappear on screens, Nō robes and *kosode* fabrics, furnishings and utensils. These motifs may be regarded as symbols of certain sentiments shared by a society. They are the objects and phenomena that develop certain frames of reference, a shared language that evolves with familiarity and tradition. It is as though each motif represents a kind of national emotional consensus, and knowledge of what kind of sentiment or association each should prompt is intuitive to those born into the tradition.

In the West, many motifs found in art are drawn from religious or mythological subjects, or iconography, of Greek or Judeo-Christian source. The motifs which figure with equal prominence and power in the art and poetic psyche of Japan, relative to the West, go beyond religious and mythological subjects and themes. Temporal, secular phenomena, such as autumn grasses, maple leaves, and specific places known for natural beauty such as Uji and the Tatsuta River are part of the national aesthetic sensibility. Referred to throughout classical literature and depicted in all genres of visual art, the Japanese response to these images is immediate and profound. The Japanese perceive each motif as something laden with artistic emotions, something that is half an artistic product even before artistic transformation occurs.

To such natural objects, the Japanese impart a certain artistic artificiality. For example, the unique art of flower arrangement only slightly alters nature. What is notable here, however, is that for Japanese the flowers are artistic objects even before they are arranged. The same thing can be said of the Japanese garden, which is said to retain many more aspects of nature than the traditional landscape gardens of Europe. But again, the natural material—rock, sand, pruned tree—becomes a symbol of a certain artistic sentiment once it is chosen to be made into a garden.

It might be said that in Japan nature itself is artificial, and art itself is close to nature. With this approach, the Japanese artist incorporates motifs in his artistic repertoire. Not only decorative and fine arts, but nature and art too are profoundly interconnected.

THE JAPANESE VISION:
IMAGE AND PERSPECTIVE IN JAPANESE ART

Shigenobu Kimura

The characteristic designs in a nation's fine and decorative art traditions reveal much about a people's fundamental view of nature. Interactions between heaven, earth, and man—the triangle representing phenomena of the temporal and spiritual worlds— vary from culture to culture. Differences in this relationship to nature are based in part upon religious, intellectual, and social history, climate, and geography. As a culture articulates its vision of the natural world through art, an iconography of motifs emerges. Analyzing the recurring images in a nation's art thus reflects a distinct cultural character.

In Japan, autumn grasses and water have figured prominently in the repertoire of artistic and literary motifs since the Heian period (794-1185). Each came to symbolize aspects of nature to which the Japanese were especially sensitive. While autumn grasses embodied *mono no aware*, or the pathos of ephemerality, water represented the mystery of a constant yet ever-changing substance.

The manner of depiction and stylization of autumn grasses and water is as significant for an understanding of the "visual structure" inherent in Japanese tradition. By visual structure I mean how the perspective, thus the impression of an image is rendered.

An outstanding example of the woodblock prints which flowered in the Edo period is Katsushika Hokusai's (1760-1849) "Behind a Wave off Kanagawa." The composition of this famous print is extremely simplified: a small Mt. Fuji rises in the background far beyond a huge, toppling wave. Such a composition contrasting background and foreground entirely lacks a middle ground. This "close-up" image pictorial design is characteristically Japanese.

Generally, there are two ways of looking at things: from a distance, and at close range. By the first approach, the whole of an object is perceived in a single glance, forming a "distant image." If, on the other hand, the viewer goes extremely close to an object, only a part of it comes into his vision; to have a general impression of the object as a whole, he must move his eyes from one part to another. Here the impression of the whole is a composite of visual impressions. This forms a "close-up image," a picture by myopic vision.

Classical European perspective is "distant image." Foreground, middle-ground, and background are constructed towards a single vanishing point. From such a fixed viewpoint, only one aspect of the object comes into view. European compositions based on mathematical perspective are thus "single-aspect compositions." The illusion of space and depth is further achieved with color gradation: density and light recede with distance.

The classical Japanese pictorial design contrasts in many ways. The "close-up" image stresses surface rather than depth, multiplicity rather than unity, color uni-formity rather than color gradation.

Depth in Japanese art is not intended to unify objects observed from a distance. Rather, the Japanese artist goes closer to his object and by relinquishing the distance between it and himself tries to become one with it. The Japanese character never allowed a bystander's attitude, but impelled the overcoming of the distinction between self and object. Thus little spatial depth appears in the paintings and motifs of Japanese art, as some works by the Rimpa artist Ogata Kōrin (1658-1716) testify. Each object, whether mountains, waves, or trees is abstracted and simplified to shapes and planes. Foreground and background are presented with equal intensity and the picture as a whole has the effect of an arabesque. This flat, close range arrangement of colors and stylized forms derives a more realistic sense of atmosphere in the interest of strong, expressive design. Autumn grasses and water, whether as motifs in the applied arts or as painting subjects, are typically treated from this perspective.

The anthologies of Japanese court poetry compiled in the eighth through thirteenth centuries represent the flowering of Japanese civilization. Poems of the four seasons were accorded a prominent status among the various literary subjects. Of the seasonal poems, autumn was most favored. For example, in the tenth-century *Kokinshū* the number of poems on autumn is the greatest. The moon setting in a misty field, the cry of crickets in the grasses, the wind-blown maple leaves are among the images that most poignantly evoke the season's mood. These and the flowers and grasses which grow wild from early July to late September came to signal that which the Japanese were most keenly conscious of: the passage of time.

The so-called "seven grasses of autumn" (*aki no nanakusa*) originated in the ancient harvest festivals and rites. In contrast with the "seven grasses of spring" the autumn species were inedible. Of them, bush clover was part of the coming-of-age rite on the fifteenth of the eighth month (by the lunar calendar), when its twigs were employed to skewer symbolic dumplings. Pampas grass was used to decorate the dumplings that were offered to the moon on the evening of the same day when the moon was thought to shine the brightest. Pampas grass was also used for decoration during the many autumn festivals celebrating the harvest season. "Maiden-flower" too was used to pay tribute to the moon in some regions. The wild carnation served in the "Summer New Year" (*hayari shōgatsu*), a rite performed during those years which saw a series of misfortunes. During the summer *obon* festival, bellflowers adorned the altar to welcome the souls of the dead. The last two of the "seven grasses of autumn," arrowroot vine and hemp agrimony, were gathered and appreciated for their beauty.

Recognition of the four seasons, traditionally marked

by festivals and rites, is combined with a keen appreciation of nature. The Japanese custom of visiting mountains, rivers, fields, forests or sea coasts famous for their seasonal beauty testifies to an unusually poetic awareness of nature. In literature and art alike, scenes of the Tatsuta River, known for its maple foliage in autumn, or Yatsuhashi, known for its iris in early summer, are recalled again and again.

This intimate connection with nature is expressed in Japanese architecture. In Japan, a building that does not incorporate some part of nature inside and outside is unthinkable, but this is not necessarily so in the West. If the Acropolis and San Marco Plaza, made of stone and almost exclusive of plant life, can be considered representative of Western architecture, Western architecture may be characterized as "man-made." The Westerner's relation to nature takes the form of confrontation. In contrast, the Japanese relation to nature takes the form of assimilation. The Westerner tries persistently to carve a man-made niche in nature. If that attitude can be called "man-centered," the Japanese attitude must be called "nature-centered." The former is an attitude of man trying to maintain his existence in opposition to nature, while the latter is an attitude of man trying to merge wholly with nature.

The Japanese view of nature is monistic. The Japanese insist that animals, plants, natural phenomena, and human beings are all part of the same realm. The Western dualistic interpretation that man and nature exist in opposition to each other did not develop in Japan. Rather, a monistic view of nature produced a traditionally intimate relation to clouds, mountains, waters, and other natural phenomena that was, in turn, expressed in art and culture. Sensing felicitousness in a flower-like cloud, wishing to see Mt. Fuji in the "first dream of the year"—these and other instances reveal how the Japanese regard nature as an animate and intelligent force.

This intimacy with nature is especially manifest in the strong appeal of autumn grasses. Contrary to "withered grasses" (karekusa), a favorite topic in traditional poetry that conveys pessimism or sadness, akikusa expresses optimism and love for passing things. The beauty of autumn grasses may be expressed in one word: elegance. Unlike grandeur, tragedy, or solemnity, elegance is readily crystalized into decoration. No wonder that autumn grasses have been favored for decorative designs in Japan.

Water is a mysterious substance, changing color and shape from one moment to the next. Fluid, free, and ever-changing, water stores limitless potential for artificial transformations and metaphors. The Japanese, inhabitants of an island country that features an exceptionally wide range of water phases in its climate and geography, have responded to their en-

vironment by producing an abundant variety of water images.

The earliest examples of water motifs in Japanese art are the bell-shaped bronzes (dōtaku) dating from pre-historic times that feature patterns of water currents. The Lady Tachibana Shrine at Hōryū-ji, the seventh-century miniature shrine for Buddhist statues, features a wave pattern of a lotus pond.

By the Momoyama period (1568-1603), patterns and motifs based on shapes and phases of water were countless. These form the basis of the repertoire of water designs in Japanese fine and decorative arts. To represent ripples, for example, slow, elongated chevrons came to be used; slow curves may be stacked up; or irregular curves may be placed in a row. Elongated spirals with dots indicate stirring waves, while two rings placed back to back with two chevrons indicate "dancing" water. In general, quiet water is represented by stacks of half moons; waves of the sea by layers of chevrons; and flowing rivers by several long curving lines. The unique "blue sea wave" (seigaiha) pattern consists of stylized waves of the same shape stacked together in an extremely orderly fashion. The "blue sea wave" pattern as we now know it is said to be the creation of Seikai Kanshichi, a lacquer craftsman of the Genroku era (1688-1704). Made to indicate the image of restless waves, it represents an ultimate stylization that follows geometric precision. "Blue sea wave" patterns also came to use lozenges rather than half circles, and occasionally broken curves rather than complete curves.

The patterns of rough waves, white caps, and whirlpools have as long a history and as great a variety as those of regular waves. Of them the kata-o-nami and Kanze-mizu are most common. The kata-o-nami name comes from the calling of the upper part of a big wave the "male wave," and the lower half "female wave." This pattern consists of large and small fan-shaped waves stacked in bands. The Kanze-mizu pattern is so called because the Kanze family of Nō actors adopted the pattern as their family crest. It consists of horizontally elongated whirlpools (cat. no. 30).

Abstract wave patterns were often adopted as family crests, and incorporated into design motifs. The patterns based on water and waves usually appear as part of larger designs, such as with the "Rough beach" (araiso) and "Waterwheel" (mizuguruma) themes. The "Rough beach" depicts a wave-pounded beach where fish, plovers, and pine trees may also appear. The "Waterwheel" incorporates a waterwheel. Among the other things that may be combined with water are birds; flowering plants, such as irises, bush clover and oranges; and inanimate objects, such as a bridge or a boat. Some of these combinations have their own names, such as the "Seashore" (kaibu) and "Watershore" (suihen). These patterns are less stylized than realistic while the "Sandspits" (suhama) tend to be quite abstract.

Some of the pictorial motifs depicting seashore and waterside scenes represent actual places famous in poetry, such as Uji River, Tatsuta River, or the Eight Views of Ōmi. Each design aims to enhance the appropriate literary flavor. Certain motifs are more popular than others at a particular time. The Yatsuhashi design which alludes to an episode in the *Tales of Ise*, of the tenth century, was a particularly fashionable motif in the Edo period (cat. no. 38).

If things that are separate from man, including transcendental concepts, can be summarily called nature, then Western art which distinguishes man and nature may be said to approach nature as design. The result is representational art based on perspective. In Japan, however, where the relation between man and nature is quite intimate, design tends to merge into nature. In other words, Western design is traditionally created with nature as its object. In that scheme, nature exists first, followed by a representative design. But in Japan the gestalt or unified form such as autumn plants or water comes first. Japanese designs are thus, for the most part, more stylized and abstract than narrative and realistic.

The Japanese artist neither copies nature nor defines a concept. He attempts to abstract not the "matter" (*koto*) but the "thing" (*mono*). The description of "matter" is visual, while the formation of a "thing" is tactile. It is natural that the Japanese artist, who regards a painting or a design not as something to be observed, but as an *objet*, should be more tactile than visual, more thing-oriented than matter-oriented. Strong interest in the real and temporal world is an expression of this view of nature.

THE TEMPORAL VIEW OF THE WORLD IN JAPANESE ART

Toyomune Minamoto

The Japanese are distinguished for being emotional and assimilative in their reflection of man and nature. In Japanese art, man and nature are not objective, but subjective images. In Chinese art, nature is regarded as a simplicity or tranquility that transcends banal reality. This derives from the Chinese spiritual or ethical attitudes. Whereas the orthodox monochrome Chinese landscape painting (*sansui-ga*) represents a "metaphysical landscape" in "metaphysical color" that rejects sensuality, based on a denial of realistic humanism, nature in Japanese art is assimilated by human feelings.

In the West, human concerns dominated the fundamental view of the world and traditionally man has been the essential subject of Western art. The human body, the nude in particular, has been depicted since ancient Greece, imparting an element of sensuality even to religious themes.

The Western view, which places man in the center of a three-dimensional physical world, has two characteristics that are not found in Japanese art. One is realism that depicts the subject as an objective form; the other is expressing the subject in space. In Japanese art the subject is simplified and distorted in disregard of objective accuracy. Also, in Japanese art neither the physical volume of the subject nor the depth that indicates the relative spatial position of the subject is expressed. The Japanese term *e-soragoto* (*e*, "painting"; *soragoto*, "falsehood"), which may be translated as "painter's fiction," suggests that art is not necessarily expected to convey reality, and that art is thought to exist in a realm separate from objective reality. With few exceptions, realism in the Western sense did not exist in Japanese art until the middle of the nineteenth century when realistic techniques of European painting were introduced to Japan.

The scientific methods of conveying three-dimensional space were not known in Japan. In traditional art, therefore, varying depths are expressed by the relative placement of objects, with lower ones being nearer, and higher, farther. This explains the absence of horizon line in Japanese painting. In this, Japanese landscape painting shares a common characteristic with Chinese.

There is, however, a great difference between Japanese and Chinese art. Essentially, Chinese art has a much higher density of expression than Japanese. It has an internal solidity, technical meticulousness, and mental profundity. In contrast, Japanese art is characterized by plainness and clarity, which in turn derives from Japanese attitudes. The Japanese character is optimistic and social. On the other hand, it is a temperament singularly lacking in tenacity. Its traits are simple, clean, and light, just as in Japanese cuisine.

For the Japanese, water meant waves. With a two-dimensional perception of space, the Japanese did not think of presenting the state of water as a three-dimensional expanse. Waves were the favorite state of water, while other forms were depicted as a flat spread of blue pigment. Whereas waves are likely to be perceived as a mass in European art, they were perceived as a combination of lines in classical Japanese art. Such rhymical curves are essentially decorative and have much capacity for displaying the variety, flair and wit of water designs.

For the Japanese, enjoying art was traditionally nothing less than enjoying life. Unlike the Chinese, who took an ethical position, Japanese people imparted to their art a delightful, decorative nature. In the West, where the basic ideal is to capture reality, decorative arts have long been treated as minor arts. But in Japan, decoration was all. While a decorative product had a utilitarian, rather than purely artistic, mission, it did not lose its artistic quality for that.

The decorative nature of Japanese art is evident even in representational works. In the twelfth-century "Illustrated Tale of Genji Scroll," the oldest extant example of illustrated court literature, the drama of the characters is subordinated to the elegant compositions of each scene. Even the "Burning of the Sanjō Palace" (Museum of Fine Arts, Boston) of the mid-thirteenth century, shows a decorative touch amidst the realistic action scenes.

The Momoyama period (author's preferred dates, 1570-1620) was the age when ordinary people acquired an economically and culturally significant status in Japanese society. Subject matter of painting expanded. In addition to the Chinese-inspired monochrome ink landscapes or bird and flower themes in color, a new interest in genre subjects arose, spurred on by demand of the new merchant class patrons. Many of the screen and door panel paintings from this period are brilliantly-colored decorative works.

The "Plain of Musashi" screens (cat. no. 2) display this essentially decorative quality of painting of the sixteenth and seventeenth centuries. It used to be said that Musashi Plain was so vast and grassy that one saw the moon rise from the grass in the east, and set into the grass in the west, an image described in the following anonymous poem:

> The moon has no hills to set behind in Musashi Plain;
> it rises out of the grass, sets in the grass.

The screens represent the typical theme of a Kyoto capital dweller's image of the unseen country. The lower halves of the paintings are taken up by pampas grass of equal height, and sprinkled throughout the pampas grass are autumn plants favored by the Japanese such as chrysanthemums, bush clover, bellflowers, and "maiden-flowers." The upper halves are covered by the decorative device known as "Genji cloud" or "golden cloud," which became popular after the middle of the

sixteenth century. There are two other conspicuous features about these paintings. One is Mt. Fuji rising from the gold cloud of the left screen, and the other, the silver moon shining through the pampas grass of the right screen. Overall, decorative intentions are evident. It may be added that paintings based on such a theme were extremely popular in those days.

But in such paintings the Japanese artist was not merely interested in wittily effecting decorative designs; he was interested in expressing poetic, or literary, sentiments. In the Musashi Plain screens, the artist was as much interested in conveying the literary flavor of the poem on which his pictures were based as in depicting the landscape of a particular locale.

Autumn grasses are the plants that the Japanese people have favored since the ancient days. They are common, familiar, diminutive, and graceful—the characteristics equally applicable to Japanese art. The autumn grasses are so popular, indeed, that they continued to be a favorite subject matter even in the Momoyama period, when energetic, foreceful, and heroic themes were favored in art. The designs of tiny dew drops sprinkled among the leaves of autumn grasses decorate some of the lacquerwares in this catalogue. Dew, symbolic of the fleeting and the diminutive, also evokes poetic sentiments. The basic reason for the Japanese preference for autumn grasses is that they are emblematic of autumn laden with emotion, when things come to the end of their year's journey. The ripe ears of pampas grass have "bloomed" into silvery *obana* "tail flowers." Their supple bent stalks and swaying leaves create a graceful symphony of curving lines. The Japanese traditionally have a temporal view of the world. This philosophic stance accounts for the emphasis in Japanese arts on narrative developments and seasonal changes. Much as they have appreciated spring, Japanese have been moved more deeply by autumn as the "time of parting." Thus the art of autumn grasses is a product of a unique Japanese aesthetic.

PLATES AND CATALOGUE

AUTUMN GRASSES

Autumn, *aki*, has been the season most celebrated in Japanese poetry, painting, and design. According to the traditional lunar calendar, the season begins in the seventh month with the first stirrings of a cool breeze and lasts until the ninth month, when frost settles on chrysanthemums and fallen maple leaves cast hills and streams deep crimson.

Yet the beauty of these changes in the natural world does not completely account for the prominence of autumn imagery in the arts.

Momokusa no	The flowers of a myriad grasses
Hana no himotoku	Have loosened their "sashes"
Aki no no ni	On the autumn fields—
Omoitawaremu	Do not blame me
Hito na togame so.	For wishing to play with them.

<div align="right">

Anonymous
Kokinshū 4:246

</div>

This poem from the first imperial anthology of poetry (compiled in 905) presents a field of autumn grasses in imagery both descriptive and suggestive. Were the poem illustrated, the painting might depict noblemen lounging and riding horses in a field. The poetic sentiment of the scene alludes rather to infatuation and young love.

But the *Kokinshū* poet's enchantment with the sight of autumn flowers belies a strong tinge of melancholy associated with the season. The very word for autumn, *aki*, is homophonous with a verb meaning "to grow weary of." An autumn poem by the extraordinarily gifted court lady and author of *The Tale of Genji*, Murasaki Shikibu (ca. 973-1014?), expresses a typically feminine perspective on the season:

Okata no	Think of me
Aki no aware o	In the common pathos
Omoiyare	Of an autumn sky,
Tsuki ni kokoro wa	Even though your heart
Akugarenu tomo.	Be captured by the moon.

<div align="right">

Murasaki shikibu shū 95

</div>

The second line, *aki no aware*, can be read as "the sadness of rejection," while the moon may refer to another woman. (Bowring, *Murasaki Shikibu*, p. 246). A painting illustrating this poem might depict a solitary woman gazing idly at the moon above her garden. Both poems, while ostensibly about autumn, express the authors' feelings about love. Autumn appears not as the subject of these poems, but as metaphor for human emotions.

Images of autumn in poetry and painting trace their origins to the *Man'yōshū*, the first collection of Japanese poetry and song (compiled ca. 754). The poetic sentiments recorded in *Man'yōshū* reappear in the *Kokinshū* and the slightly later *Tales of Ise*, a fictionalized poem-tale about the romantic adventures of the poet Ariwara no Narihira (825-880). Murasaki Shikibu, herself a descendant of a *Kokinshū* poet, wove the courtly narrative of *The Tale of Genji* around themes, images, and poems from *Kokinshū* and *Ise*. Later writers—whether poets, Nō dramatists, or authors of Edo period fiction—would continually refer to these Heian works for fresh inspiration. The classics of Japanese literature, *Genji* and the great poetry anthologies, were the source for design motifs throughout later periods and in all genres of fine and applied Japanese art. A certain composition—a carriage parked in a bank of autumn grasses, a willow tree by a flowing stream—alluded to a specific literary scene and was meant to evoke those special sentiments associated with it.

Aki no no ni	Flowers blossoming
Sakitaru hana o	On autumn fields—
Oyobi ori	Were I to count them
Kaki kazoureba	On my fingers
Nanakusa no hana.	They would number seven.
Hagi no hana	The flowers of bush clover,
Obana kuzubana	"Tail flower," and arrowroot,
Nadeshiko no hana	Wild carnations,
Ominaeshi	"Maiden-flowers,"
Mata fujibakama	Also "purple trousers" and
Asagao no hana.	"Morning face."

<div align="right">

Yamanoue Okura (ca. 660-733)
Man'yōshū 8:1537-8

</div>

This *Man'yōshū* poem is the earliest of many lists of the autumn grasses (*akikusa*) favored by poets. Yet the poet could not actually have seen all seven flowers blossoming either at the same time or in the same place. These wild plants of the moors and roadsides came to be cultivated in the gardens of the Heian aristocracy, for once their names assumed poetic nuances, they were a favorite source of poetic inspiration. They were often too included in love-letter packages.

Of all the autumn grasses, perhaps bush clover (J. *hagi*, L. *Lespedeza*) was most favored because of its delicate, ephemeral flower. The Chinese character for bush clover, invented in Japan, is composed of two elements: autumn (*aki*) and grass (*kusa*). Thus the character *hagi* defines bush clover as *the* autumn grass. A large woody shrub that grows wild on mountains and plains, the branches are long and overhanging, light enough to sway in the wind. Small, round green leaves grow in threes. Pink flowers shoot from the ends of the branches in early autumn, and soon after scatter in the wind or perish with the dew (cat. no. 15). There is no more poignant scene in Heian art and literature than Chapter 40 of *The Tale of Genji*, "The Rites." Genji's beloved wife Murasaki lies on her deathbed, visited by Genji and the Empress, his daughter. The three direct their thoughts to the bush clover growing in Murasaki's garden as they exchange their poetic farewells.

Oku to miru	So briefly rests the dew
Hodo zo hakanaki	On the bush clover
Tomo sureba	Even now
Kaze ni midaruru	It scatters
Hagi no uwa tsuyu.	In the wind.
Yayamoseba	In the haste we make
Kie o arasou	To leave this world
Tsuyu no yo ni	Of dew,
Okure saki datsu	May there be no time
Hodoezu mo gana.	Between the first and the last.

(Seidensticker, *The Tale of Genji*, p. 717.) The corresponding scene from the twelfth-century "Illustrated Tale of Genji" handscroll (now in the Gotō Art Museum, Tokyo) shares with the poetry the dichotomy of inside and outside, human emotion and natural world. Genji, Murasaki, and the Empress appear in a room to the right, while the wind-tossed bush clover dominates the garden to the left. Without knowledge of the poems, the painted scene cannot be fully appreciated.

While bush clover is a metaphor for the brevity of human life, "tail flower"—better known as eulalia or pampas grass (J. *susuki*, L. *Miscanthus sinensis*)—until the modern age served utilitarian purposes as thatch roofing or as fiber woven into sacks or mats. Pampas grass is very common and grows in summer with long curving green leaves and in autumn with golden tassels that rise up toward the sky spreading open like the hairs of an animal's tail (cat. nos. 1, 2, 19). In winter, as the tassels whiten, the leaves wither under snow. Fields of golden tassels beckoning in the wind, covered with dew or glowing softly in the moonlight are favorite poetic images.

Nobe tōki	Wide across the moors
Obana ni kaze wa	Bend the tassels of the
Fukimichite	pampas grass
Samuki yūhi ni	In the swelling breeze;
Aki no kureyuku.	And in the cold of the evening sun
	Autumn darkens to its close.
	Lady Jūsammi Chikako
	Gyokuyōshū 5:819

(Brower and Miner, *Japanese Court Poetry*, p. 380.)

The roots of the arrowroot vine (J. *kuzu*, L. *Pueraria thunbergiana*) yield a fine white powder used in cooking. The reddish-purple flowers, resembling those of bean plants, bloom in late summer, but were little noted by poets and painters. Instead, it was the broad lobed leaves blowing in the breeze that captured the artistic imagination (cat. no. 21). Dark green on top, the underside is distinctly white. "When the wind blows the arrowroot leaves, one can see that their backs are extremely white and pretty," remarked Sei Shōnagon, author of *The Pillow Book* (early eleventh century). (Morris, *The Pillow Book of Sei Shōnagon*, vol. 1, p. 60.) The blowing leaves could also stand for changes in a lover's affection:

Aki kaze no	Seeing the back of
Fuki uragaesu	arrowroot leaves
Kuzu no ha no	Turning over
Uramite mo nao	In the autumn wind,
Urameshiki kana.	I am desolate.
	Taira no Sadabumi
	Kokinshū 15:823

In autumn these same leaves turn brilliant crimson.

Chihayaburu	Even the arrowroot vines
Kami no igaki ni	Clinging to the sacred fence
Hau kuzu mo	Of the lofty gods
Aki ni wa aezu	Can not hold against
Utsuroinikeri.	Autumn's change of color.
	Ki no Tsurayuki
	Kokinshū 5:262

Wild carnations, often called fringed or wild pinks (J. *nadeshiko*, L. *Dianthus superbus*) have a decidedly childish air about them. Small fringed petals, five in number, grow in clusters on thin stems. Their petals are usually bright pink, although white is also seen (cat. no. 4). The name literally means "pat a child on the head," and the soft fringed petals invite touching. While Yamanoue Okura included wild carnations in his list of autumn flowers, *Man'yōshū* poems treat them as both summer and autumn blossoms. Later they appear almost exclusively in summer contexts. There are several varieties of wild carnations, each with different names and associations. A wide-petal variety (*Kara nadeshiko*) was imported from China, and has the alternate and highly suggestive name *tokonatsu*, "always in summer," with a word-play on *toko* which also means "bed." The slender-petaled flower is the "Japanese carnation" (*Yamato nadeshiko*), often found in poetry describing a man's young lover.

Once again an exchange in *The Tale of Genji* shows how flowers function as a metaphor for human concerns. In Chapter 2, "The Broom Tree," Genji's rival Tō no Chūjō tells the story of a former love who bore him a child. Not having seen him for some time, she sent a poem with a wild carnation attached.

Yamagatsu no	The fence of the mountain rustic
Kaki wa aru to mo	
Oriori ni	May fall to the ground.
Aware wa kakeyo	Rest gently,
Nadeshiko no tsuyu.	O dew
	Upon the wild carnation.

Moved, Tō no Chūjō visited her and tried to reassure her,

Saki majiru	No bloom in this wild array
Hana wa izure to	Would I wish to slight.
Wakanedo mo	But dearest of all
Nao tokonatsu ni	To me
Shiku mono zo naki.	Is the wild carnation.

(Seidensticker, *The Tale of Genji*, p. 33.) In the woman's poem, the wild carnation (*nadeshiko*) refers to the child, but in his poem Tō no Chūjō cleverly shifts the wording from *nadeshiko* to *tokonatsu*, so that his wild carnation is the woman.

Even more suggestive of femininity by its name and appearance, "maiden-flower" (J. *ominaeshi*, L. *Valerianaceae; Patrinia scabiosaefolia*) often elicits flirtatious banter. Tall stems a meter in height fan out symmetrically at the top bearing tiny five-petaled flowers that grow to resemble miniature parasols (cat. no. 3). Their delicate sway in autumn breezes enhances this impression of femininity. A long sequence of poems in *Kokinshū* plays upon the erotic connotations of the flower's name.

Na ni medete	"Maiden-flower,"
Oreru bakari zo	I only plucked you
Ominaeshi	For your lovely name.
Ware ochiniki to	Do not let on
Hito ni kataru na.	I fell for you.

Priest Henjō
Kokinshū 4:226

Ominaeshi	If I linger
Ōkaru nobe ni	In this field
Yadoriseba	So full of "maiden-flowers,"
Ayanaku ada no	I may well gain
Na o ya tachinamu.	A wanton reputation.

Ono no Yoshiki
Kokinshū 4:229

Translating the name of the flower known in Japanese as *fujibakama* (L. *Eupatorium fortunei*) to the English "hemp agrimony," while preferable to "boneset" or "thoroughwort," hardly conveys its poetic nuances. The literal translation is "purple (wisteria) trousers" and therein lies the flower's interest. Tiny white blossoms tinged with purple grow on tall stems, resembling those of the "maiden-flower." Lower leaves are serrated along the edges and grow in threes (cat. no. 6). A relatively scarce plant with a fragrant flower, hemp agrimony was also worn on the body as a medicinal sachet. Poems usually exploit both the connotations of the name and fragrance, and usually refer to a man, rather than a woman.

Yadori seshi	These "purple trousers"—
Hito no katami ka	Are they a memento
Fujibakama	From he who spent the night?
Wasuraregataki	How often I catch
Ka ni nioitsutsu.	Their unforgettable scent.

Ki no Tsurayuki
Kokinshū 4:240

The last of the seven autumn flowers, "morning face" suggests by its name the familiar morning glory, a creeping plant with trumpet-shaped blossoms and large heart-shaped leaves (cat. no. 8). Morning glories were not native to Japan, but were imported from China during the Heian period. In *Man'yōshū* and in most Heian poetry, "morning face" apparently referred to the so-called "Chinese" bellflower or balloonflower now called *kikyō* in Japanese (L. *Platycodon grandiflorum*). An early autumn flower, the five-pointed, trumpet-shaped blossoms are generally purple, but white is also common (nos. 2, 7). They are not vines, but rather grow on low stems with symmetrical leaves. The word *kikyō*, being of Chinese origin, does not appear in poetry. "Morning face" poems usually speak of the brevity of the flower's blossom:

Ware narade	Though your affections be
Shitahimo toku na	ephemeral
Asagao no	As the morning glory's
Yūkage matanu	flower,
Hana ni wa ari tomo.	Gone before sunset,
	Do not loosen your
	under-sash
	For anyone but me.

Ariwara no Narihira
Tales of Ise

(McCullough, *Tales of Ise*, p. 95.)

In the eighth century poem of autumn flowers, there is one notable absence: the chrysanthemum (*kiku*). Even a casual glance through this catalogue shows that this flower was equal to or greater in prominence than several of the so-called autumn grasses. In fact, there are no references to chrysanthemums in *Man'yōshū* at all, nor was the flower native to Japan. Love for the chrysanthemum and its poetic imagery were imports from China, and can be found at first only in Japanese poetry written in Chinese. These few lines of farewell to an envoy from the Korean Kingdom of Silla were written before 729:

The cicadas are hushed, the cold night wind blows;
geese fly beneath the clear autumn moon.
We offer this chrysanthemum-spiced wine in hopes
of beguiling the cares of your long return.

Abe no Hironiwa
Kaifūsō

(Watson, *Japanese Literature in Chinese*, vol. 1, p. 22.)

The imagery of chrysanthemum wine is associated with an age-old belief in China that an elixir made of chrysanthemums conferred long life, if not immortality. In a story of the Han dynasty (206 B.C.-A.D. 220), chrysanthemum blossoms dropped into the waters of a stream and those who then drank the water lived to be hundreds of years old. The ninth of the ninth month was set aside as a day for drinking chrysanthemum wine and wishing the emperor long life. This custom was adopted in Japan in the year 807, and thereafter became part of the "schedule of yearly observances" (*nenjū gyōji*).

It was also during the ninth century that chrysanthemums became assimilated into native poetry. In the last decade the court held a chrysanthemum contest that celebrated and judged the varieties of cultivated chrysanthemum flowers and poems composed on the

occasion. One of Japan's greatest poets, Sugawara no Michizane (845-903), particularly loved chrysanthemums and wrote a masterful poem on this occasion:

Akikaze no	In the autumn breeze
Fukiage ni tateru	Dotting the beach at Fukiage
Shiragiku wa	White chrysanthemums:
Hana ka aranu ka	Are they blossoms, or perhaps
Nami no yosuru ka.	Only waves that are breaking there?

Kokinshū 4:272

(Watson, *Japanese Poetry in Chinese*, vol. 1, p. 125.)

By the thirteenth century, the chrysanthemum became the symbolic crest of the imperial family. As a motif alone or with other elements, such as water, the chrysanthemum was favored thereafter in textile, lacquer and painting designs.

In the fourteenth century, a Buddhist priest and sensitive writer on court tradition and aesthetics, Yoshida Kenkō (1283-1350), mused on the plants he preferred in his garden:

Among autumn plants I prefer reeds, pampas grass, bellflowers, bush clover, valerian ["maiden-flowers"], hemp agrimony, asters, burnet, lemongrass, gentians and chrysanthemums. Yellow chrysanthemums are also good. Ivy, arrowroot vine, and morning glories are all best when they grow on a low fence, not too high nor too profusely. It is hard to feel affection for other plants—those rarely encountered, or which have unpleasant-sounding Chinese names, or which look peculiar. As a rule, oddities and rarities are enjoyed by persons of no breeding. It is best to be without them. (Keene, *Essays in Idleness*, pp. 123-126.)

Kenkō's list of flowers includes the *Man'yōshū* seven (wild carnation appears in his summer list), chrysanthemums, and several other varieties. Clearly his affection for each plant derived from their familiarity to eye and ear alike. His disdain for oddities with Chinese names is understandable, since such plants would be distinctly out of place in the native poetry he was fond of composing. Kenkō's love for the traditional, ordinary varieties of autumn plants was shared by countless others who, for generations, chose these motifs for textile, ceramic, and lacquerware designs, or decorative screens. If the Heian period saw the establishment of autumn imagery in poetry, painting and design, art forms of later periods would continue to build upon that foundation.

K.L.B.

1.
PAMPAS GRASS
Muromachi period
Pair of six-fold screens; colors on paper
H. 150.0 × W. 361.0 cm., each
Private Collection, Japan

Tall, gently swaying stalks of pampas grass play gracefully across the surfaces of these two screens. The large-scale composition extends beyond all but the upper edges. The lack of a well-defined ground allows the viewer to sense being in the middle of a field, barely able to see over the tips of the surrounding grasses. Deep green leaves with generous flowing curves dominate, while the thin stems and white tassles fade into the darkened paper ground. In some spots green paint has worn away to reveal outline underdrawing. Close examination of the surface of these screens reveals more than thirty faint black, square outlines. These indicate that *shikishi*, sheets of decorated paper approximately 18 cm. square, should have been attached to the painted surface. Such papers might have been decorated with seasonal motifs and inscribed with poems brushed by aristocratic calligraphers.

The practice of pasting poem-inscribed papers onto screens began during the Heian period, when screen paintings often occasioned the composition of poetry. (The reverse is also true; a poem sequence could generate one or more screens.) Poetry anthologies and details of interiors in narrative picture scrolls are today the only clue to the appearance of early screens, since none have survived. One screen might have had several small vignettes scattered across six panels and connected by an expansive landscape setting. The individual scenes often depicted seasonal activities, such as rice planting or an outing on an autumn field, with all details rendered in miniature scale. Poems, composed to complement, celebrate or explain the painted scenes, would be written on poem-papers and affixed to the screens. The viewer could enjoy the scene and the poetry simultaneously.

By the fifteenth century, the traditional intimate juxtaposition of painting and poetry had undergone a series of changes. Poetry was still inscribed on *shikishi* and attached to screens, but the poems were selected from earlier anthologies and bore no relationship to the painting, now relegated to the status of underpainting. Contemporary diaries record that autumn grasses were perceived as the most appropriate subject for such poem screens. Yet this practice was not limited to *shikishi*; fan paintings of seasonal and narrative subjects, such as *The Tale of Genji*, were equally popular. The placement of poems or narrative paintings on the screens could have followed a seasonal, rather than historical or narrative, progression moving from spring on the right through summer and fall to winter on the left.

Autumn grasses as underpainting was only one way in which screens changed from the Heian to the Muromachi periods. In early screens, autumn grasses were miniature accents in a larger scene that often included figures, animals, or architecture. Although a detail in the twelfth-century illustrated *The Tale of Genji* scroll, Chapter 48 "Young Ferns" (Tokugawa Reimeikai Foundation), shows pampas grass and Chinese bellflowers painted in large-scale on a sliding door panel, this decorative usage of the autumn grass motif may have been adopted from contemporary designs for calligraphy paper. Autumn grasses were probably not painted in large scale as the only subject of a screen until the fifteenth century. Pampas grass screens, without poem-papers attached, are documented in contemporary records, and are seen in details of domestic interiors painted in the narrative scrolls of the court artist Tosa Mitsunobu (ca. 1430s-1523) and his followers. The Suntory screens are the earliest extant examples of the pampas grass subject and of underpainting for poem-papers.

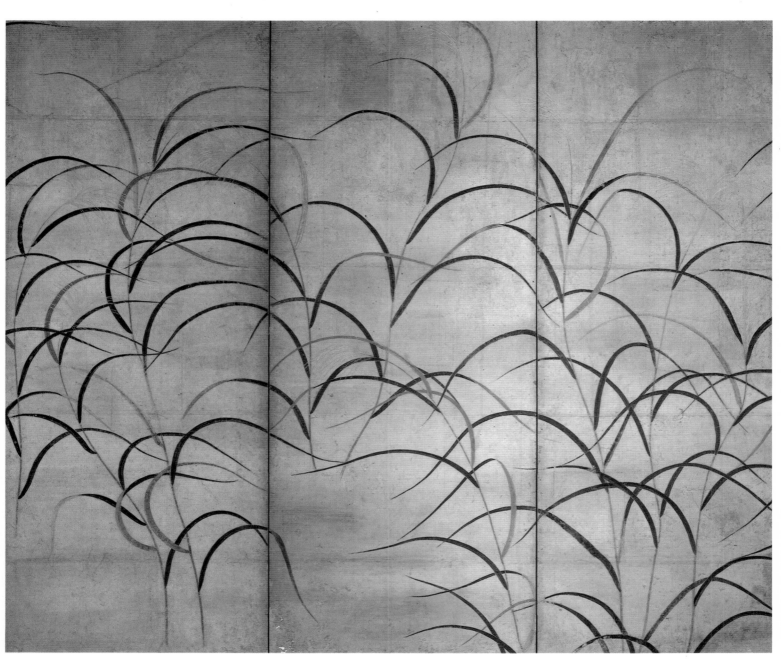

Detail

2.
PLAIN OF MUSASHI
Edo period, eighteenth century
Pair of six-fold screens; colors and gold on paper
H. 175.0 × W. 382.0 cm., each
Suntory Museum of Art

Bush clover, blue and white Chinese bellflowers, and small chrysanthemums are scattered in a field of green pampas grass. A silvery full moon rises behind the grasses of the right screen, reflecting its light on the distant snow-capped peak of Mt. Fuji, seen through a break in the golden clouds of the left screen. The composition is divided into three horizontal zones: gold clouds along the top, heavy green pigment along the bottom, and the middle ground sprinkled with flakes of gold *(sunago)*. The gold leaf of the right screen appears as a flat surface so that only its scalloped edge behind the grasses suggests clouds. In the left screen, the golden clouds separate and take on the form of mist. In both, the flat expanse of gold denies any suggestion of depth.

The theme of this pair of screens is Musashino (Musashi Plain), the vast plain that once stretched across the expanse of Edo, modern Tokyo. Although an occasional subject of Heian poetry and painting, Musashi Plain and the province of that name were remote from the Heian imperial capital. A poem about

Musashino in the first imperial anthology of poetry, *Kokinshū*, suggests that the place was then famous for its purple gromwell (J. *murasaki*, L. *Lithospermum erythrorhizon*), the root of which is the source of a rich purple dye.

Murasaki no	Because of a single
Hitomoto yue ni	Murasaki plant,
Musashino no	I look with affection
Kusa wa minagara	On all the grasses
Aware to zo miru.	Of Musashi Plain.
	Anonymous
	Kokinshū 17:867

(McCullough, *Tales of Ise*, p. 220.) The purple color of the *murasaki* plant could only be worn by officials of the highest rank and breeding. In this poem, and in many others based on it, *murasaki* denotes the poet's beloved. Another poetic image of Musashi Plain was of wind blowing across its withered fields, and by extension, of a love affair that had turned cold and distant.

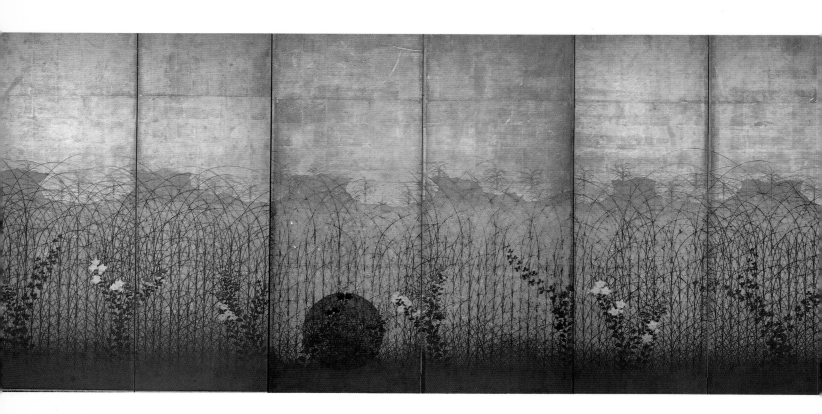

Aki kaze n'o	Musashi Plain
Fuki to fukinuru	Swept and swept
Musashino wa	By the autumn wind—
Nabete kusaba no	Every single blade of grass
Iro kawarikeri.	Has faded.

<div align="right">

Anonymous
Kokinshū 5:821

</div>

An eleventh-century visitor traveling through Musashi Plain was not impressed, however. Known to posterity as Sugawara no Takasue's daughter (1008-after 1059?), the author of the *"Sarashina Diary"* made an uncommon journey from the remote eastern province of Kazusa to the Heian capital in 1020.

> We were in Musashi, a province without a single charming place to recommend it. On the beach the sand was not white but a sort of muddy color; in the fields, there were none of the *murasaki* plants I had heard about, but just a mass of reeds growing so high that even the tops of our horseman's bows were invisible. (Morris, *As I Crossed a Bridge of Dreams*, p. 43.)

With the growing prominence of Eastern Japan in the late twelfth century, first-hand knowledge of Musashi spread. A poem by the aristocrat Minamoto Michikata (1189-1238) describes the place with a new image that was to capture the imagination of poets and artists thereafter:

Musashino wa	On the Musashi Plain
Tsuki no irubeki	There is no peak
Mine mo nashi	For the moon to enter—
Obana ga sue ni	White clouds catch
Kakaru shirakumo.	In the tips of "tail-flowers."

<div align="right">

Shokukokinshū 5:427

</div>

Michikata's poem created the popular image of Musashi Plain with his merging of the grasses motif and the moon. An often-quoted poem of the seventeenth and eighteenth centuries carried the imagery further by changing the last two lines:

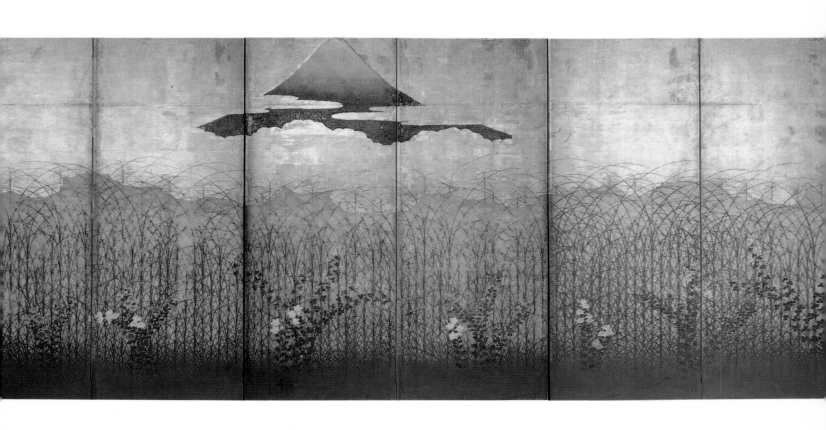

3.
AUTUMN GRASSES
Attributed to Ogata Kōrin (1658-1716)
Edo period, early eighteenth century
Pair of two-fold screens; colors and gold on paper
H. 170.0 × W. 190.0 cm., each
Suntory Museum of Art
Important Art Object

Autumn grasses were a favorite motif of artists of the Rimpa (literally, "school of Kōrin") tradition. In the early seventeenth century, Tawaraya Sōtatsu (active ca. 1602-1640) and the calligrapher Hon'ami Kōetsu (1558-1637) collaborated to create a fresh reinterpretation of classic Japanese design. They worked in a wide range of media, including fan paintings, printed books, lacquer, and ceramics. A series of poem-papers (*shikishi*) and horizontal scrolls decorated by Sōtatsu with gold and silver designs have classical Japanese poetry written on them by Kōetsu. Many such poem-papers, decorated with designs of individual autumn grasses, may now be seen pasted on screens with autumn grasses underpainting (cat. no. 1). Sōtatsu's immediate follower, Tawaraya Sōsetsu (active ca. 1639-1650), specialized in screen paintings of lush autumn fields, with as many as twenty different plants and grasses. A century later, paintings of this subject by Ogata Kōrin, though freer in execution, exploited Sōsetsu's vision. Kōrin's designs—for screens, textiles, fans, and ceramics—became popular and set the style for later Rimpa artists to emulate.

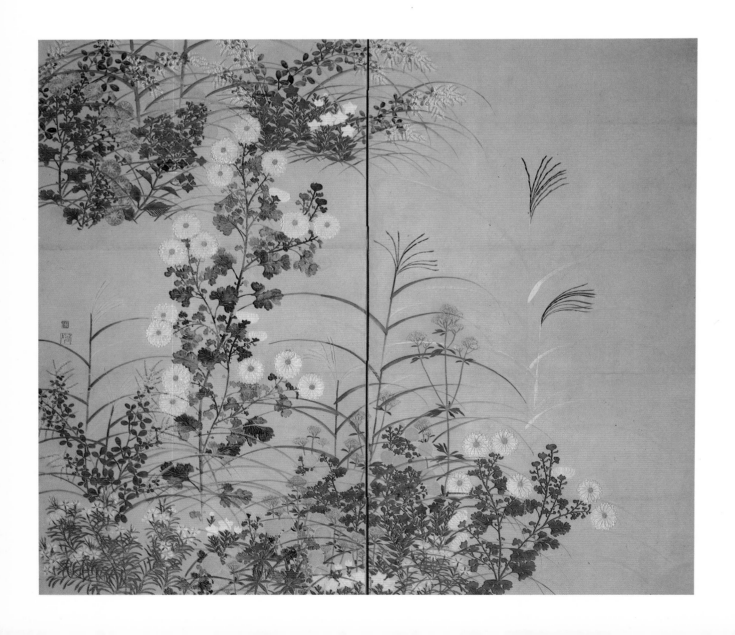

This pair of two-fold screens illustrates several of the flowers and grasses of autumn: large white chrysanthemums, smaller yellow, pink, and white field chrysanthemums, pink and white bush clover, yellow "maiden-flower," blue and white Chinese bellflowers, pampas grass with pink or black tassels, and pink-tinged wild carnations. The artist arranges the grasses and flowers in clusters suggestive of depth, but without supplying the ground plane. A variety of techniques are used to paint the flowers: gold line for pampas grass, ink wash for chrysanthemum leaves, and opaque color for leaves and flowers. The surfaces of the large chrysanthemums are built up (moriage) with shell-white (gofun).

At the outer edge of each screen are two seals: the intaglio square seal reads "Ogata;" the relief square seal reads "Kansei." The former is an early rendering of Kōrin's family name, while the latter is one of the artist's pseudonyms. The work is, however, unsigned by the artist and the attribution has yet to be confirmed.

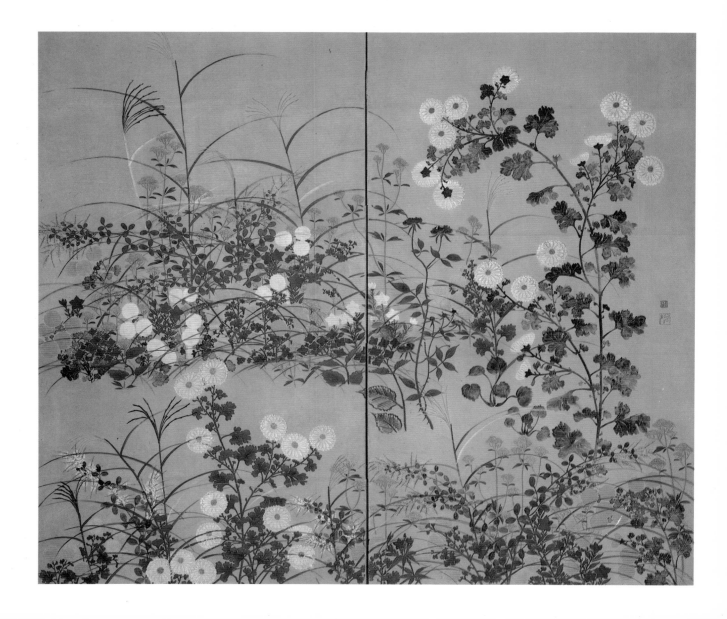

5.
**NŌ ROBE (KARAORI TYPE) WITH DESIGN
OF AN AUTUMN FIELD**
Edo period
Silk twill patterned in weft floats *(karaori)*
H. 157.0 cm.
Eisei Bunko Foundation

The illusion of autumn grasses growing on an ex-
pansive field is accentuated by horizontal lines that
appear throughout the design to indicate ground. Pull-
ing against this sense of depth is the overall design of
rust-colored ivy which floats across the surface. The
autumn grasses repeat in a variety of muted colors irre-
spective of their natural hues. For example, the leaves
of bush clover and wild carnation appear in white, an
effective contrast to the three colors of the section-
dyed twill ground that alternate at the seams *(dan-
gawari)*. The muted colors give the robe a decidedly
autumnal cast while suggesting horizontal bands of light
and mist. This robe would be worn in an autumn play,
where it would be appropriate for the role of a middle-
aged or elderly woman.

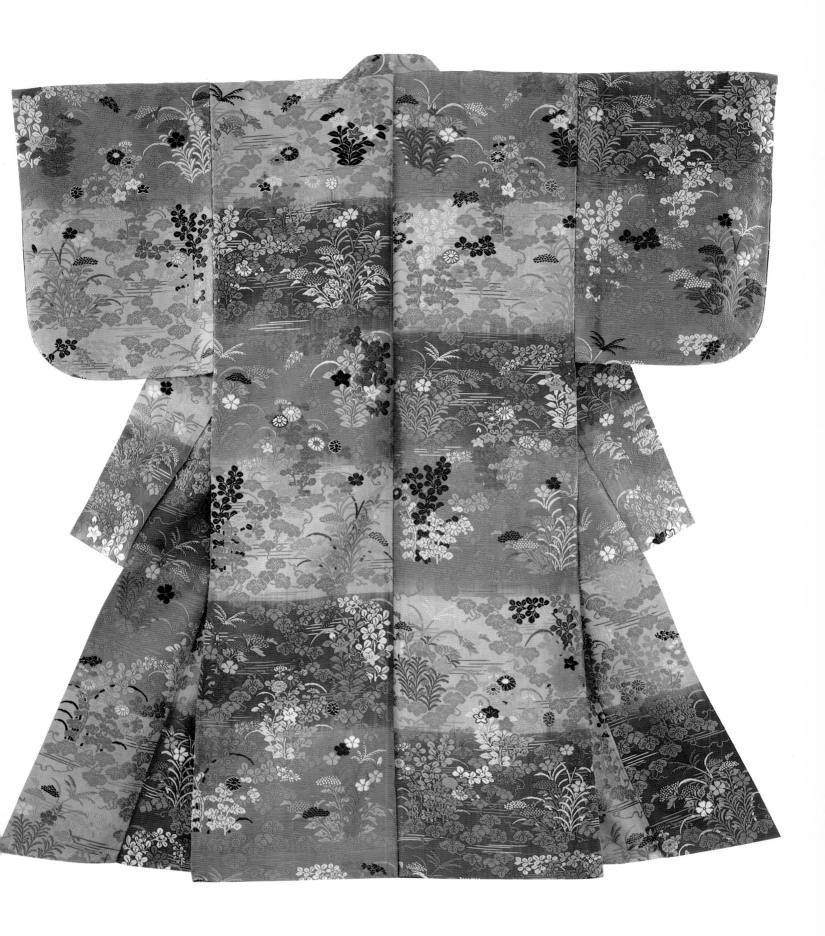

41

6.
NŌ ROBE (*NUIHAKU* TYPE) WITH DESIGN
OF AUTUMN GRASSES
Edo Period
Embroidery and metallic foil *(nuihaku)* on plain-weave silk
H. 146.0 cm.
Eisei Bunko Foundation

Nuihaku (literally "embroidery" and "foil") refers to robes decorated in a combination of embroidery and gold or silver foil appliqué. The term also denotes a type of inner robe which may or may not be decorated in this technique. In this robe, several gold foil patterns fill the surface area, the patterns changing in accordance with the different ground colors: fishnet on red; tortoise shell on white, and interlocking links on pale blue-grey. Most of the gold foil has worn away, but shadowy patterns left by traces of paste remain. The section-dyed ground does not alternate, as in the case of the autumn field *karaori* (cat. no. 5), but instead has been aligned to create strong horizontal stripes across the entire robe.

Scattered clumps of chrysanthemums, Chinese bellflowers, bush clover and hemp agrimony are embroidered on top of the gold-patterned fabric. Each cluster of grasses was originally set off by a bamboo fence, but, perhaps because of the dye used, the thread weakened and has been lost. The random diagonal lines of the bamboo staves would have created an effective contrast to the delicate curves of the grasses.

Nuihaku robes were worn underneath the stiff heavy *karaori*. Depending on the role, more or less of this inner garment would have been visible to the audience. For roles involving a mad woman, the top of the outer robe was slipped off one or both shoulders and left to hang from the belt tied at the waist. The *nuihaku*, moreover, could also be worn off the shoulders to reveal yet another inner robe decorated solely in gold or silver foil appliqué (*surihaku*, cat. no. 30).

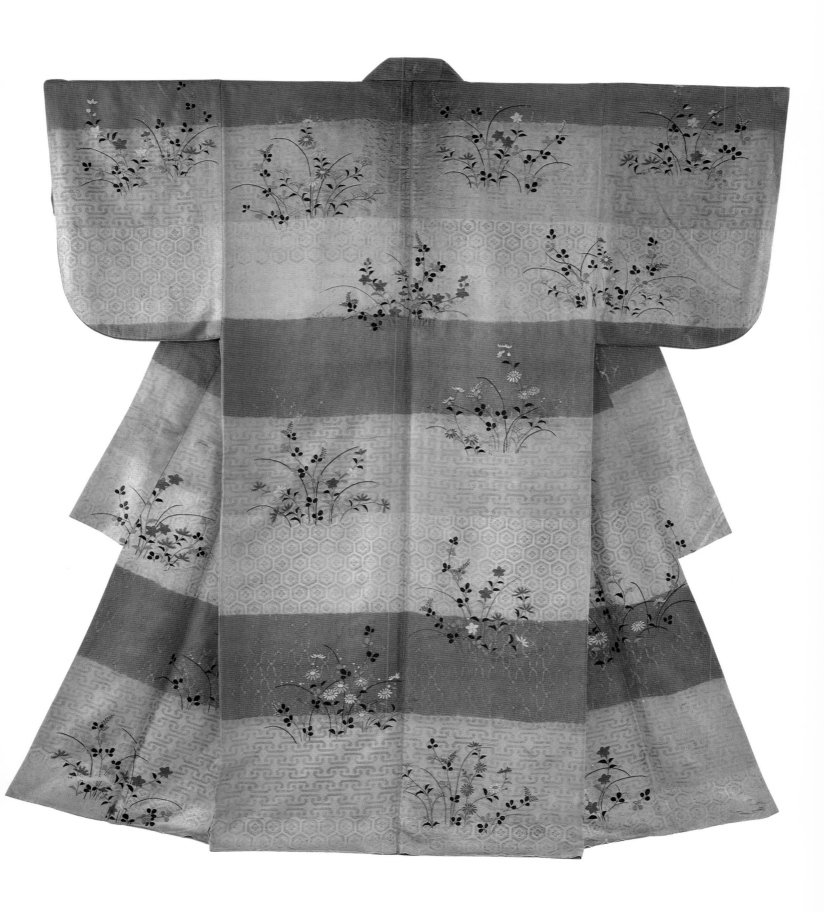

43

7.
KYŌGEN COSTUME (*KATAGINU* TYPE) WITH DESIGN OF MOON AND AUTUMN FIELD
Edo Period
Stencil-dyed hemp
H. 77.7 cm.
Private Collection, Japan

Setting into a field of blooming bellflowers and dense pampas grass, a huge autumn moon identifies the design on this sleeveless short vest as the Plain of Musashi (cat. no. 2). The flowers and pampas grass are stencil-dyed in large repeating patterns; the moon is rendered in rice-paste resist. The crisply silhouetted bellflowers in particular capture the line, shape and mood of Rimpa design (cat. no. 3). The reduction of color to blue-green and white gives the garment an ethereal, moonlit quality.

Sleeveless vests such as this would be worn for the role of the head servant (*tarōkaja*) in Kyōgen, the comic interludes between Nō plays. The bold stencil designs and the coarse hemp cloth were especially appropriate for Kyōgen, in which many of the roles are rustics. The contrast between the stately and otherworldly quality of Nō and the bold earthiness of Kyōgen is reinforced in the materials and designs of their respective costumes.

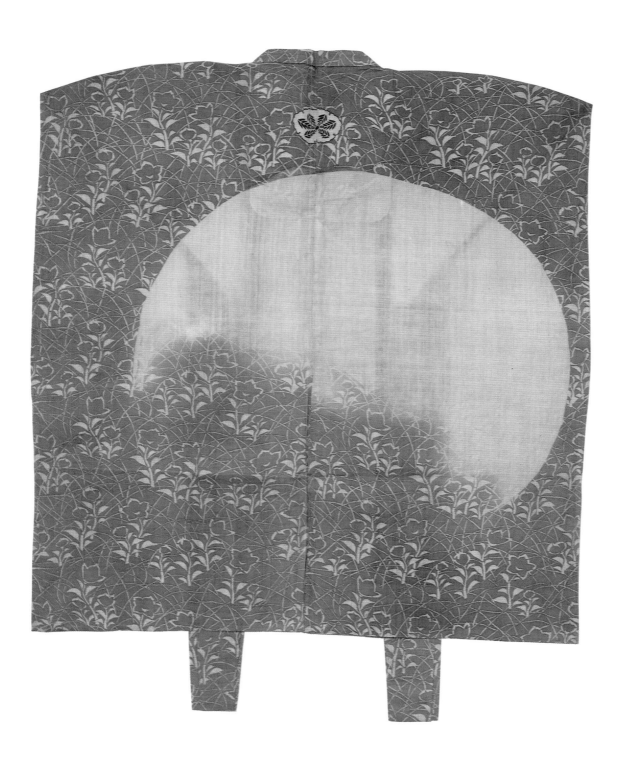

45

8.
**KYŌGEN COSTUME (KATAGINU TYPE) WITH DESIGN
OF CART WHEELS AND MORNING GLORIES**
Edo Period
Stencil-dyed hemp
H. 78.4 cm.
Eisei Bunko Foundation

Bold ox-cart wheels in deep green frame opposite corners of this sleeveless vest. A delicate, carefully drawn light green morning glory vine connects the two wheels, an allusion to the missing axle. The motif of wheels (katawaguruma) alone or floating in water has poetic origins in the Heian period (cat. no. 39). When this costume is worn, the wheels would be set in motion and the actor himself would take the place of the body of the carriage.

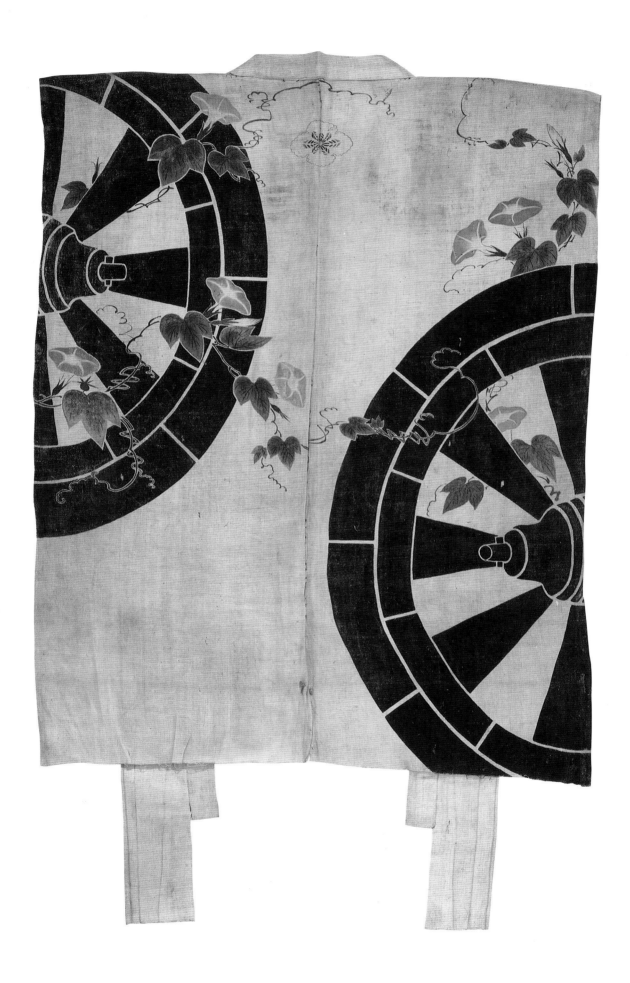

9.
TOILETRY CASE (TEBAKO) WITH MEDALLION DESIGNS
Kamakura period, mid-thirteenth century
Black lacquer on wood with gold *maki-e*,
mother-of-pearl inlay; silver rings
H. 23.0 × W. 36.0 × L. 27.0 cm.
Suntory Museum of Art
National Treasure

This splendid toiletry case for a noblewoman epito-mizes lacquer design and technique of the mid-thirteenth century. The exterior medallion pattern, known as *fusenryō* ("floating line twill"), derives from woven textile designs in use at least two centuries earlier. The large medallions contain four smaller circles that resemble flowers. The pointed four-petal flower in the center of the four circles is characteristic of the *fusenryō* pattern. The inner surface of the lid is decorated with designs of flowers and grasses, a lovely glimpse into thirteenth-century floral motifs. In addition to autumn plants—wild carnations, chrysanthemums, maple leaves, bush clover, Chinese bellflowers, hemp agrimony, and pampas grass—spring and summer plants such as cherry, plum, and peony also appear. The designs are a

visual counterpart to poetic lists of seasonal flowers.

During the Heian period, toiletry cases were used as containers for a woman's personal possessions. In addi-tion to combs, brushes, boxes of powder and rouge, tweezers, a small mirror and other toiletries, a lady's books, writing paper, or perhaps a recently-arrived love letter could also be found within. By the thirteenth century, the form and function of these boxes were standardized. The rectangular, full shape of the box, its rounded corners, and gently domed, flush-fitting lid are typical features of *tebako*. The rims of lid and box alike are banded with a protective strip of tin. The sides turn inward at the base, raising the body. On each side, silver rings for attaching a cord are worked with pine, bamboo, crane and tortoise designs against

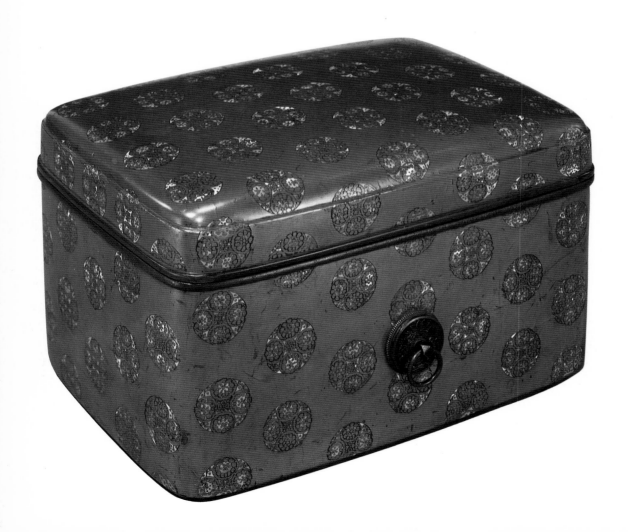

a "fish-roe" ground of tightly packed circles. This box probably contained one or more fitted trays and smaller boxes, now missing, whose designs echoed those of the *tebako* itself.

This box exhibits a variety of techniques that deserve explanation, since they appear in various combinations on all of the lacquer objects in this catalogue. The body is wood covered with several layers of lacquer, the refined sap of the *Rhus vernicifera* tree. The flat gold ground was produced by sprinkling gold particles onto the damp lacquer surface. The general term for sprinkled decoration is *maki-e* ("sprinkled picture"), while this particular method of producing gold ground is known as *ikak-ji*. The mother-of-pearl inlay (*raden*) against the rich gold ground is a technique documented as early as the eleventh century.

The ground for the interior lid is black lacquer sprinkled with fine flat gold dust (*hirame-ji*). The floral designs were produced in the oldest of *maki-e* techniques, *togidashi* or "polished-out" design, a technique in which gold was first sprinkled onto patterns drawn in damp lacquer. When hardened, they would be covered with one or more layers of lacquer and allowed to dry. The surface was then polished with abrasives to reveal the gold patterns. This time-consuming technique results in gold designs that appear flush with the surface. All of the fine black lines within the designs were painstakingly left in reserve (*gakiwari*) in the black lacquer ground.

Interior of lid

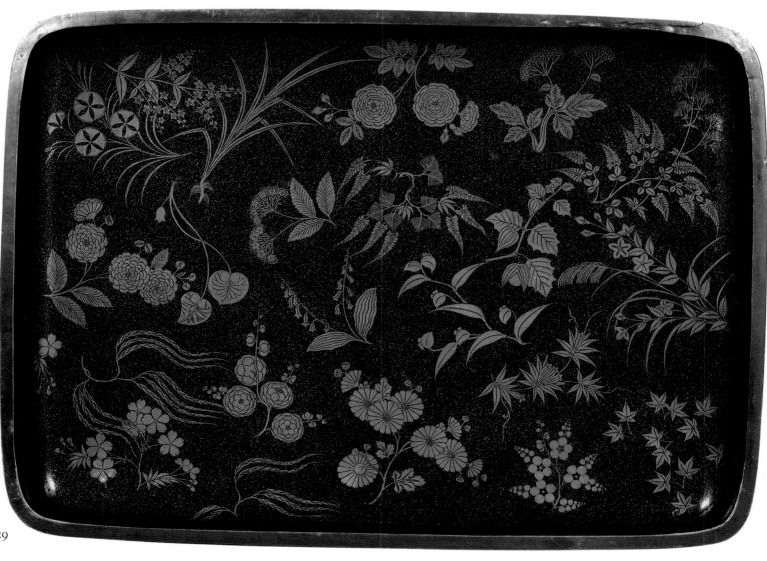

10.
MELON-SHAPED INCENSE BURNER (AKODA KŌRO) WITH DESIGN OF AUTUMN GRASSES
Muromachi period, sixteenth century
Black lacquer on wood with gold *maki-e*,
silver inlay; bronze screen
H. 9.0 x D. 11.0 cm.
Suntory Museum of Art

The body of this small incense burner is six-lobed, like a melon in shape. Gilt-bronze rims the opening, upon which rests a bronze screen that resembles a fish weir (cat. no. 27). Chrysanthemums, bellflowers, bush clover, "maiden-flowers," and pampas grass adorn the surface, highlighted by inlaid silver representing dew-drops. The ground is entirely covered in sprinkled gold. The low relief in the design of grasses is created by building up lacquer mixed with thickening powders before it was sprinkled with gold (*takamaki-e*).

The small scale of this incense burner, as well as its design and technique, prompt the suggestion that it may originally have been among the accoutrements of a toiletry case. If so, it could have been used to burn gallnut into powder for the dye used in blackening teeth. A symbol of womanhood and high birth, teeth blackening was practiced at least as early as the tenth century and remained a custom in Japan until the modern era.

11.
WRITING TABLE (*BUNDAI*) WITH DESIGN OF CHRYSANTHEMUMS
Muromachi period
Black lacquer on wood with gold *maki-e*,
silver and gold inlay; bronze fittings
H. 8.5 × W. 54.8 × L. 31.4 cm.
Suntory Museum of Art
Important Cultural Property

The flat, oblong surfaces of low writing tables particularly invited pictorial decoration. This composition, weighted in the left half, is representative: large chrysanthemums on slender stalks sway over a gentle stream. Water ripples about a few scattered rocks as silver-tinged mist weaves in among the leaves and flowers. Chrysanthemums, though adopted early into Japanese gardens, poetry, and design, retained a traditional association with China. Unlike many other examples of Muromachi lacquer, the exact poetic reference for this design is unknown.

The ground surface is black lacquer embedded with gold particles to produce a mottled effect known as "pear-skin ground" (*nashi-ji*). Chrysanthemums and rocks are raised in relief, here and there accented with inlaid bronze and silver. The mist and earthen bank were done as "polished out" designs embellished by small particles of cut gold and silver (*kirikane*), which appear also in some of the chrysanthemum centers.

The gold lines for the ripples of water and the petals of the inlaid flowers are produced by first drawing lines in damp lacquer and then sprinkling them with fine gold particles (*tsukegaki*). The outline borders and edges are covered in more densely sprinkled gold.

This writing table is among the earliest examples of its type. Narrative picture scrolls of the Heian and Kamakura periods show similar low tables in use on wood floors or tatami mats, with scrolls or books placed on them. The dimensions of the top would be appropriate for viewing scrolls, assuming the reader is sitting on the floor. By the Muromachi period, some tables were made with a matching inkstone case that contained an inkstone, water dropper, ink and brushes (cat. no. 28). It seems probable, given the uneven, elaborate surfaces of this table and the custom of writing on papers spread on the floor, that such tables more often served as stands for inkstone cases, scrolls, and books than as writing surfaces.

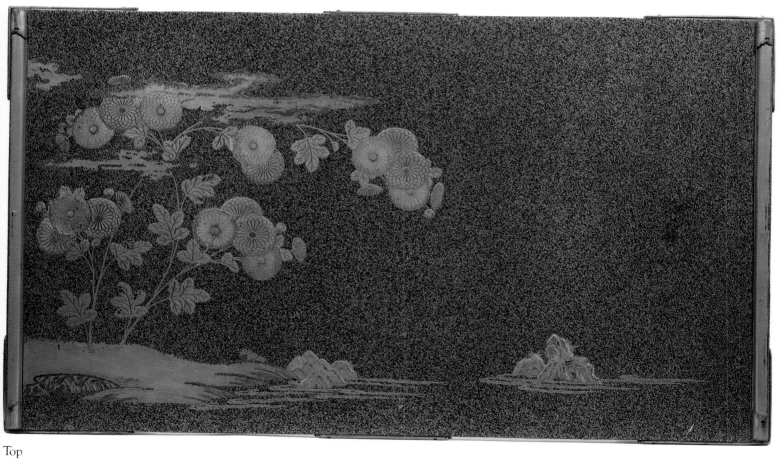

Top

12.
**DOCUMENT CASE (*FUBAKO*) WITH DESIGN
OF AUTUMN GRASSES**
Momoyama period
Black lacquer on wood with gold *maki-e*
H. 7.5 × W. 7.5 × L. 38.7 cm.
Suntory Museum of Art

This document case, and the eight lacquer items that follow, are representative of a style, technique, and decoration associated with Kōdai-ji, in the eastern foothills of Kyoto. This temple and mausoleum was founded in 1606 by Kita no Mandokoro (d. 1624), widow of Toyotomi Hideyoshi (1536-1598), the unifier of war-torn Japan who dominated politics and culture in the last decades of the sixteenth century. The interior of the ancestor hall at Kōdai-ji houses portrait statues of the couple enclosed in lacquer shrine boxes, and the room itself is lavishly ornamented with lacquer balustrades, stairs and other fittings brought from Hideyoshi's castle at Fushimi, destroyed in 1623. The date of 1596 and signatures of artists of the Kōami family of lacquer artists have been found scratched in inconspicuous spots among the lacquer furnishings. In addition to the portrait shrines and architecture, a collection of thirty personal items including a stationery box, toiletry case, and food service vessels were donated to the temple by Kita no Mandokoro.

The term "Kōdai-ji *maki-e*," originally applied to objects associated with the temple, came to designate any lacquerware of similar artistry from the Momoyama and early Edo periods (cat. nos. 12-20). There are three different styles of lacquer associated with Kōdai-ji: that primarily decorated in flat gold designs (*hiramaki-e*) on black ground, that in relief design with gold inlay (*takamaki-e* and *kanagai*), and that in low relief. The first group is the broadest category, which the objects in this catalogue represent. Autumn grasses are the

primary design motif of Kōdai-ji lacquerware, particularly chrysanthemums, pampas grass, and bush clover. They are often combined with a random pattern of paulownia leaf crests, adopted by Hideyoshi as his family crest (cat. no. 19). The designs are rendered boldly with leaves and flowers generally appearing as if pressed flat to the surface.

Technically, Kōdai-ji lacquerwares show a simple but effective use of the medium. The large number of surviving works in this style suggests that the technical simplifications were a response to greater demand. In general, design motifs are rendered either in flat gold or in "pictorial pear-skin ground" (*e-nashi-ji*), often in red or amber-colored lacquer. Gold outlines and interior lines are achieved by a denser sprinkling of gold particles on lines drawn in wet lacquer. Interior lines which appear black were scratched in with a needle (*harigaki*), rather than in the older technique of leaving black lines in reserve.

This long and narrow box was used for documents, letters or perhaps even a picture scroll. The domed cover overlaps the lower half of the box, affording the contents an extra layer of protection. The middle of each long side is cut out to accommodate the large metal rings that hold the cord. A tall stalk of chrysanthemum grows with bush clover against a background of dewy pampas grass extending over the top and down the sides. This is a relatively early object in the Kōdai-ji style, and an excellent example of its kind.

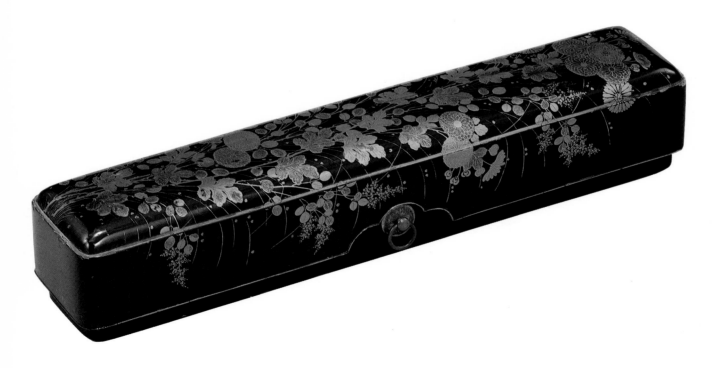

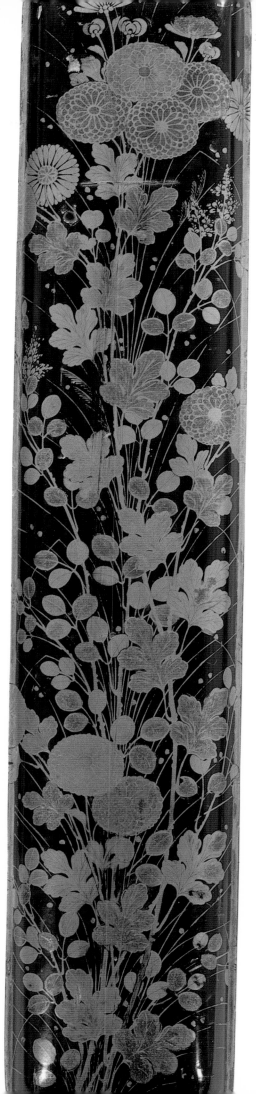

55

13.
SMALL LIDDED BOX (*KOBAKO*) WITH DESIGN
OF CHRYSANTHEMUMS AND PAMPAS GRASS
Momoyama period
Black lacquer on wood with gold *maki-e*
H. 10.0 × W. 14.0 × L. 17.0 cm.
Suntory Museum of Art

Two stalks of chrysanthemums framed by pampas grass adorn the lid and sides of this exquisite box. Perhaps once among the contents of a toiletry case (cat. no. 9), it might have contained combs or other small objects.

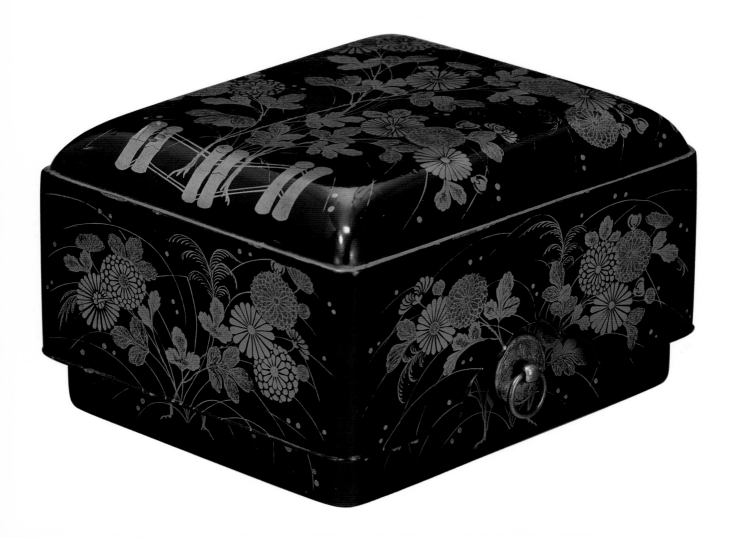

14.
INCENSE CINDER CONTAINER (*TAKIGARA-IRE*) WITH DESIGN OF MIST AMID AUTUMN GRASSES
Momoyama period
Black lacquer on wood with gold *maki-e*
H. 6.5 x D. 8.0 cm.
Suntory Museum of Art

This tiny box was used as a receptacle for cinders from the fragrant wood chips burnt during gatherings devoted to savoring incense. The narrow body of the box is shaped as two sections of bamboo, widening at the lid. The design of pampas grass and chrysanthemums blowing in the wind is divided by layers of mist.

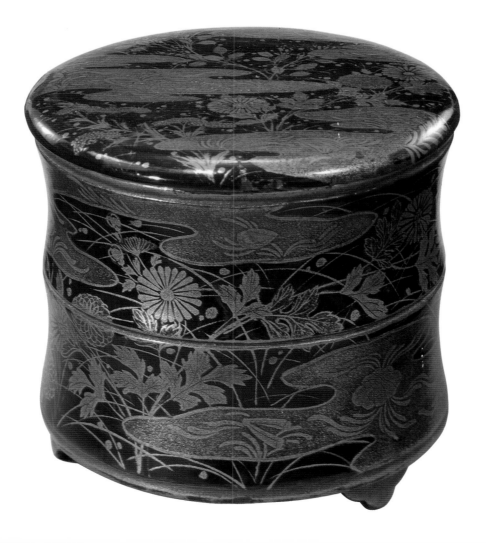

15.
BOWL WITH DESIGN OF AUTUMN GRASSES
Momoyama period
Black lacquer on wood with gold *maki-e*
H. 8.1 × D. 10.5 cm.
Suntory Museum of Art

The use of black lacquer with gold *maki-e* designs for eating and drinking utensils apparently began in the sixteenth century. Among Kōdai-ji wares still at the temple are lavish gold-decorated tables, bowls, and cups used in banquets given by Hideyoshi (cat. no. 12). This bowl is rather modest by comparison, although it is a rare example of a lacquer tea bowl. Designs of bush clover, pampas grass, and chrysanthemums decorate the black lacquer ground.

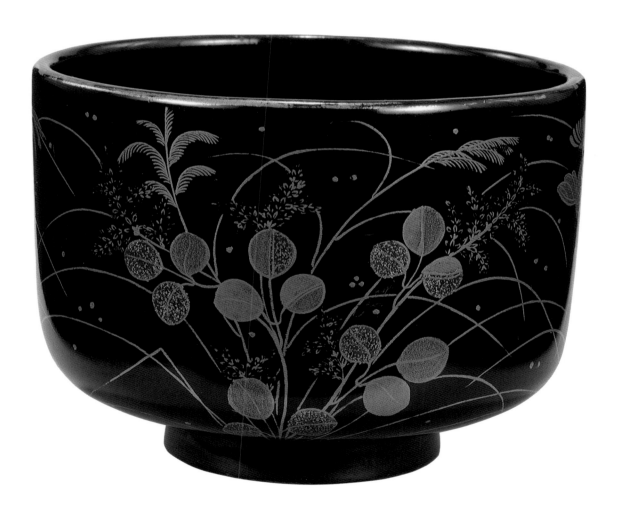

16.
FOUR-HANDLED BASIN WITH DESIGN OF
AUTUMN GRASSES
Momoyama period
Black lacquer on wood with gold *maki-e*
H. 18.5 × D. 37.3 cm.
Suntory Museum of Art

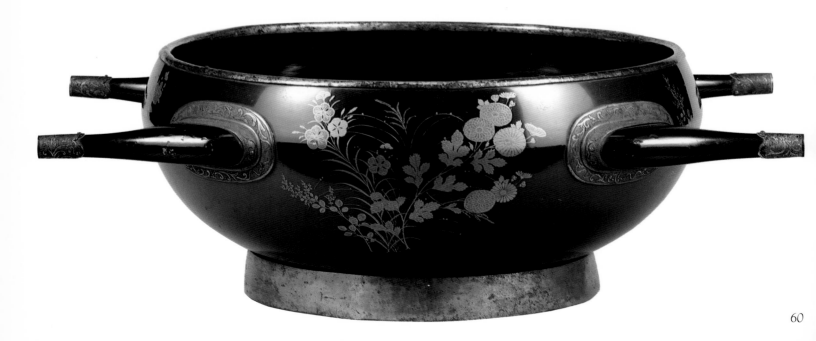

17.
EWER WITH DESIGN OF AUTUMN GRASSES
Momoyama period
Black lacquer on wood with gold *maki-e*
H. 21.5 x D. 20.0 cm.
Suntory Museum of Art

This basin and ewer form a rare set. The basin was used for face and hand-washing, the ewer for filling the bowl with water. Several picture scrolls of the Kamakura period show remarkably similar four-handled basins in use, especially in those ceremonies attending the tonsuring of Buddhist monks and nuns. Before the Momoyama period, ceramic ewers may have been more common than lacquer.

The identical raised feet and similar gilt-bronze scroll ornament and banding around the rims mark the two objects unmistakably as a set. In both examples, tall stems of autumn plants with dew display their leaves. The pictorial motifs have occasional mixtures of red or black lacquer ground, adding further interest to the design. In technique and decoration the basin and ewer derive from the standards set at Kōdai-ji (cat. no. 12).

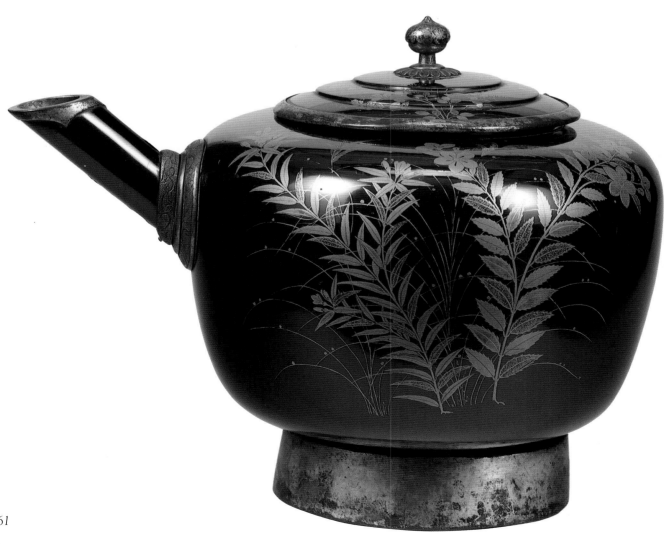

18.
**PAIR OF WINE DECANTERS (*TOKKURI*)
WITH DESIGN OF AUTUMN GRASSES**
Edo period, seventeenth century
Black lacquer on wood with gold *maki-e*
H. 21.5 × D. 10.0 cm.
Suntory Museum of Art

These lovely decanters for sake are complete with their stoppers. Although obviously a pair, the designs differ between the two. Chrysanthemums, wild carnations and Chinese bellflowers adorn one, while the other is decorated with chrysanthemums and bush clover. The designs are done in sprinkled gold and silver with scratched interior lines, or with red lacquer ground covered in fine gold particles and gold line.

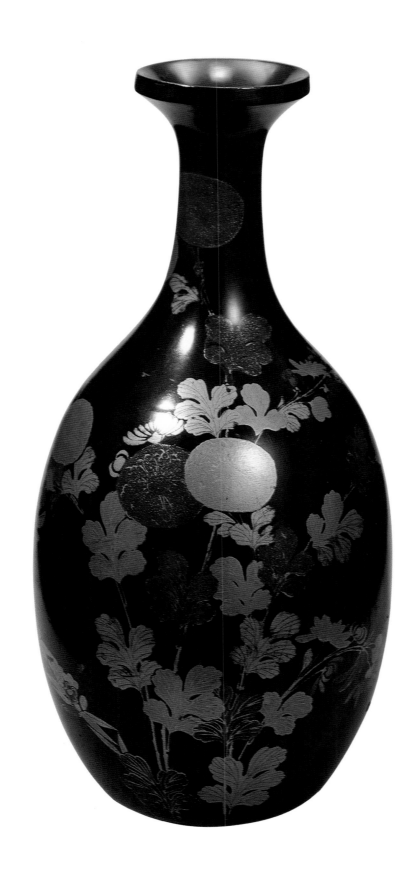

19.
**CABINET (*TANSU*) WITH DESIGN
OF PAMPAS GRASS AND PAULOWNIA CRESTS**
Momoyama period
Black lacquer on wood with gold *maki-e*;
gilt-bronze fittings
H. 50.0 × W. 38.0 × L. 30.5 cm.
Suntory Museum of Art

The paulownia crests and the thick, outlined leaves of pampas grass with large random dew-drops link this cabinet to Kōdai-ji furnishings. On each of the four sides appears one stalk of pampas grass with leaves splayed laterally. The grass on the front door of the cabinet extends onto the top surface. These motifs are rendered in flat gold and either coarse or fine *nashi-ji* in both red and black lacquer. Outlining and interior lines appear in gold.

This large chest has a hinged door, while its feet are carved from the base and side boards. The long narrow baseboard in front adorned with small paulownia leaf crests is a separate piece of wood which serves to strengthen the cabinet. Gilt-bronze hinges, fasteners and corner pieces bear designs of paulownia crests and chrysanthemums against "fish-roe" ground. Inside there are now four shelves, but traces of other shelves are evidence that this cabinet has been reworked.

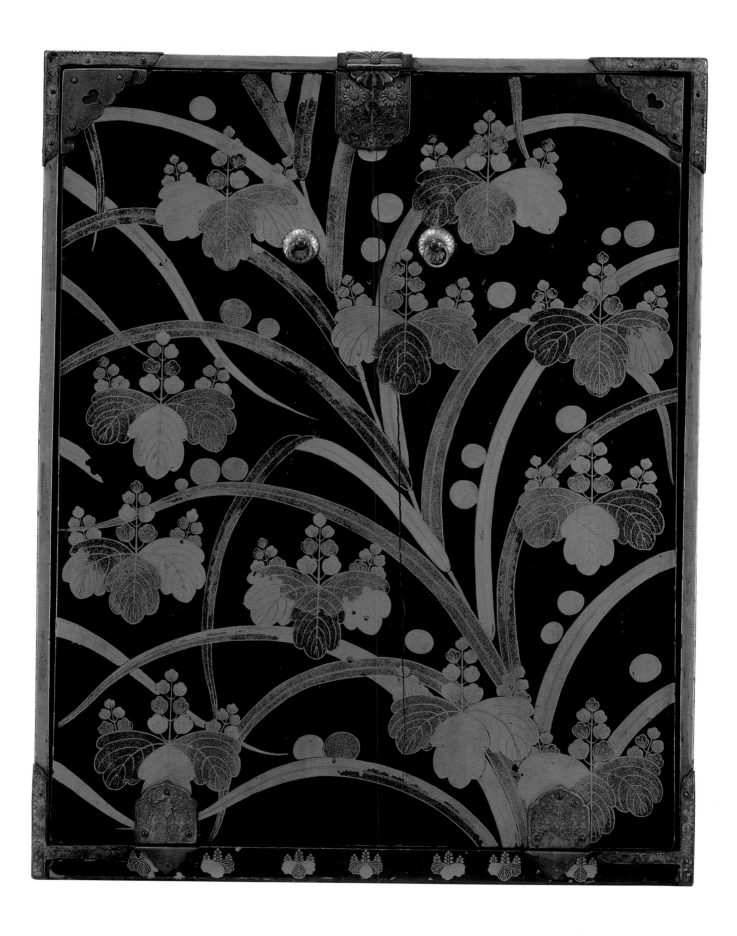

22.
TRAY WITH DESIGN OF AUTUMN GRASSES AND BUTTERFLIES
Edo period, seventeenth century
Black lacquer on wood with gold *maki-e*
H. 3.0 x D. 29.5 cm.
Suntory Museum of Art

A thicket of chrysanthemums, bush clover, pampas grass, and "maiden-flowers" gives this circular tray a definite pictorial orientation. Six butterflies hover among the flowers. The plants are arrayed in a way that suggests a familiarity with the principles of flower arranging. Red lacquer is used sparingly, resulting in an almost monotone design of gold against black. The delicacy seen in the feathery drawing of tiny leaves and petals distinguishes this tray from Kōdai-ji pieces.

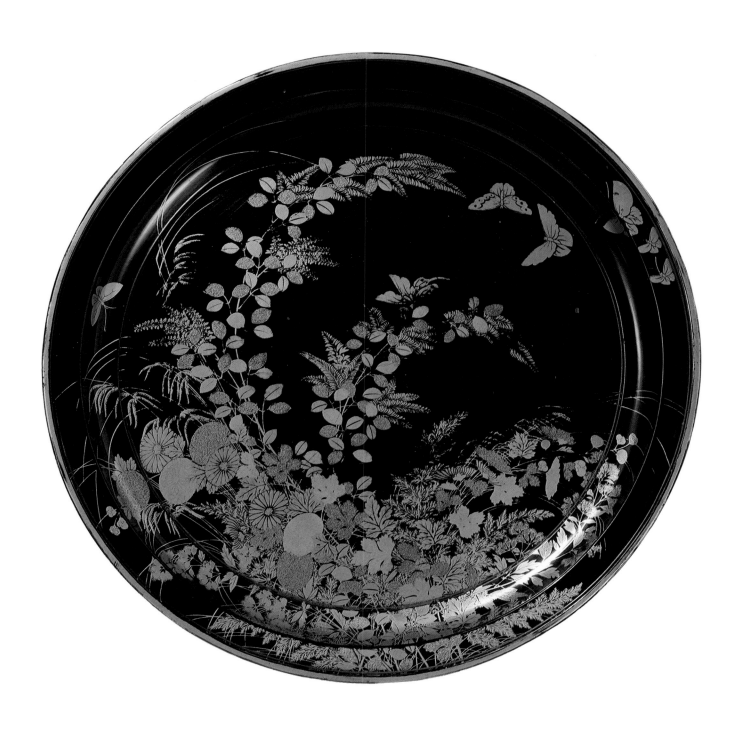

23.
INCENSE PILLOW (KŌMAKURA) WITH DESIGN OF PAMPAS GRASS AND BUTTERFLIES
Edo period
Black lacquer with gold *maki-e*, mother-of-pearl inlay
H. 17.3 × W. 22.0 × L. 12.0 cm.
Suntory Museum of Art

This pillow, consisting of an openwork box and a drawer, once contained an incense burner. A second pillow supported the neck, so that a woman's hair could trail over this pillow and be perfumed by the incense smoke. Fragrance, whether in clothes, bedding or hair, was a sign of elegant taste and refinement. Several varieties of butterflies perch and fly among the tangled grasses. Mother-of-pearl inlay combined with flat gold, *nashi-ji*, and gold line creates a rich variety of textures in the pictorial designs.

Butterflies dancing among the grasses are an especially appropriate theme for a pillow. The literary association between dreaming and butterflies originates with the Chinese philosopher Chuang Tzu (369?-286? B.C.):

Once Chuang Chou dreamt he was a butterfly, a butterfly flitting and fluttering around, happy with himself and doing as he pleased. He didn't know he was Chuang Chou. Suddenly he woke up and there he was, solid and unmistakable Chuang Chou. But he didn't know if he was Chuang Chou who had dreamt he was a butterfly, or a butterfly dreaming he was Chuang Chou. Between Chuang Chou and a butterfly there must be *some* distinction! This is called the Transformation of Things. (Watson, *The Complete Works of Chuang Tzu*, p. 49.)

Whether or not Japanese knew this famous story from the original, references to butterflies in connection with sleeping or dreaming can be found in Heian verse written in Chinese. The *Chuang Tzu* story was even more significant for its juxtaposition of waking and dreaming. In Buddhist thought all phenomena are ultimately products of consciousness, not an external permanent reality. Both Chuang Tzu's confusion and this basic tenet of Buddhism found their way into a famous episode from *Tales of Ise*. An Imperial huntsman visits Ise Shrine and receives a secret late-night visit from the High Priestess. The next morning she sends him a letter:

Kimi ya koshi	Did you, I wonder, come here,
Ware ya yukikemu	Or might I have gone there?
Omōezu	I scarcely know . . .
Yume ka utsutsu ka	Was it dream or reality—
Nete ka samete ka.	Did I sleep or wake?

(McCullough, *Tales of Ise*, p. 116.) For educated persons, even mundane objects such as this pillow could call to mind such poetic or philosophical associations.

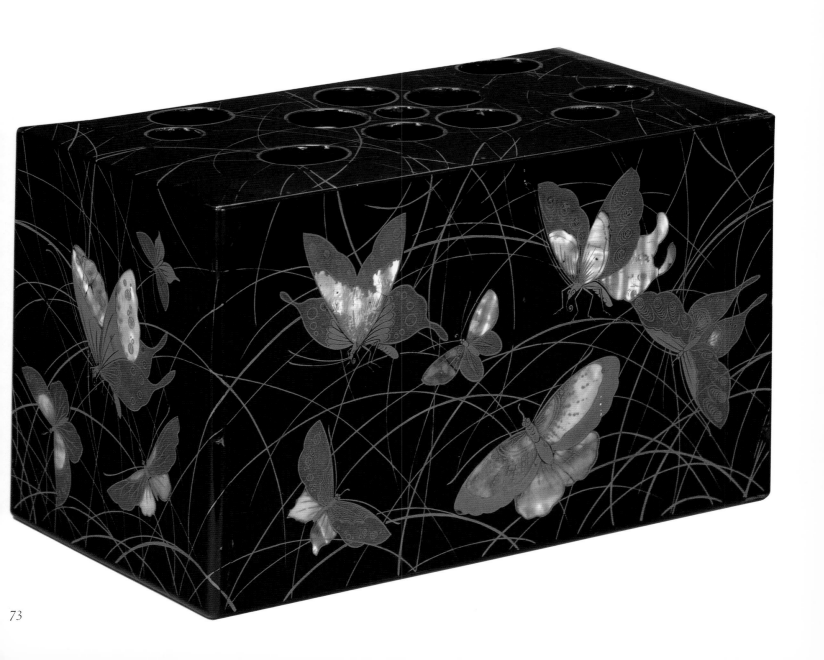

25.
PICNIC SET (*SAGEJŪ*) WITH DESIGN
OF AUTUMN GRASSES
Edo period
Black lacquer on wood with gold *maki-e*;
silver decanters
H. 29.3 × W. 28.0 × L. 19.8 cm.
Suntory Museum of Art

Outings to temples famous for cherry blossoms, to autumn fields, or to mountain areas with splendid fall foliage were a popular activity for Kyoto residents basking in the prosperity of the late Momoyama and Edo periods. Genre screens show members of all classes of society enjoying the delights of such excursions. Food and wine were essential to the occasion, which often included dance, drama, and music as well.

This picnic set contains stacked boxes, plates, cups, and two silver decanters, neatly packed in a carrying case. A rich profusion of autumn grasses decorates the case and its parts.

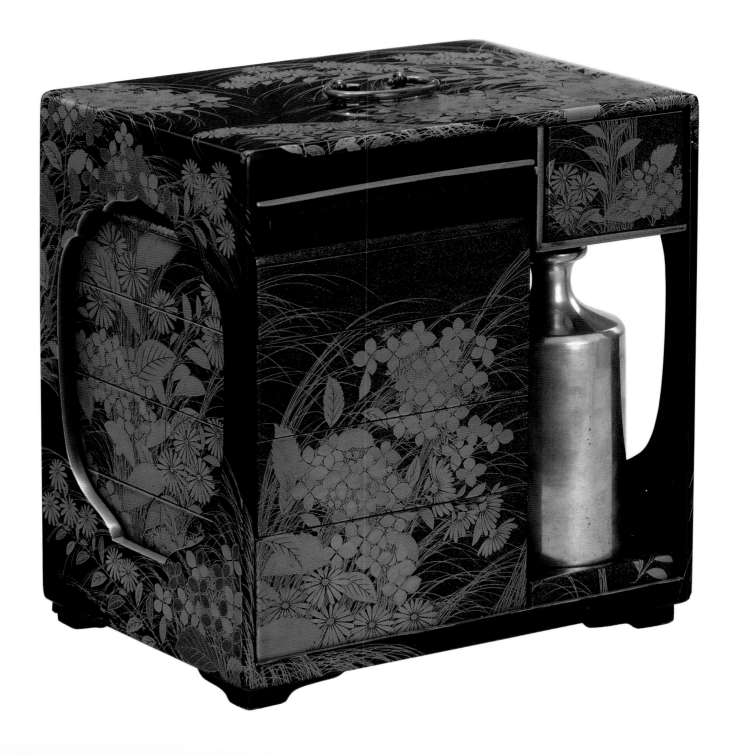

26.
INKSTONE CASE (*SUZURIBAKO*) WITH DESIGN OF "THE SHRINE OF THE FIELD"
Edo period, seventeenth century
Black lacquer on wood with gold *maki-e*, silver inlay
H. 4.5 × W. 22.3 × L. 22.8 cm.
Suntory Museum of Art

"The Shrine of the Field" (*Nonomiya*) refers to two episodes in *The Tale of Genji*, and to the Nō play of that title. In Chapter 9, "Heartvine," one of Genji's neglected lovers, the Rokujō lady, has her carriage rudely pushed about in the crush of vehicles lined up to view the Kamo Festival by men in attendance on Genji's first wife Aoi. Lady Rokujō's jealousy and embarrassment manifest themselves in a malign spirit that later brings on Aoi's death. Feeling great remorse, the Rokujō lady makes preparations to leave the capital and accompany her daughter to Ise Shrine, during the daughter's period of service there as High Priestess. In Chapter 10, "The Sacred Tree," Genji visits Lady Rokujō at the temporary shrine of purification in Sagano, just outside of the Heian capital, and entreats her not to move to Ise.

It was over a reed plain of melancholy beauty that he made his way to the shrine. The autumn flowers were gone and insects hummed in the wintry tangles . . . A low wattle fence, scarcely more than a suggestion of an enclosure, surrounded a complex of board-roofed buildings . . . The shrine gates of unfinished logs, had a grand and awesome dignity for all their simplicity . . . (Seidensticker, *The Tale of Genji*, p. 186.)

In typical Nō fashion, the play *Nonomiya* intensifies the drama of the Rokujō lady's fate. The only stage prop is a shrine gate. A traveling priest enters, and then a beautiful woman appears. Together they reminisce about Genji's visit to the lady. The woman disappears, and the sound of a carriage is heard approaching.

Nonomiya no	My carriage is bright
Aki no chigusa no	With the thousand autumn grasses
Hanaguruma	
Ware mo mukashi ni	Of the Shrine in the Fields
Meguri kinikeri.	The wheels turn; I too
	Have returned to the past.

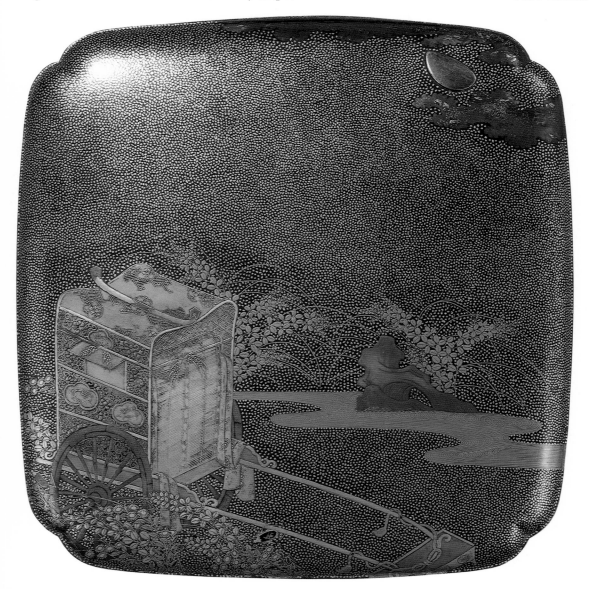

Exterior of lid

(Keene, *Nō: The Classical Theatre of Japan*, pp. 58-59.)
The woman, whom the priest now knows to be the Rokujō lady, reappears, and tells the priest the sad story of the carriages, her jealousy, and how she has been unable to achieve enlightenment. The lady wavers between the shrine gate, which would bring release, and the carriage, which symbolizes her attachment for Genji.

Although the design on this inkstone case could have drawn its imagery directly from *Genji*, the Nō play combines the critical motifs of carriage and shrine gate. On the outside of the cover a noblewoman's carriage waits empty by a stream in a field of bush clover, beneath the light of the autumn moon. Crickets perch in the bushes. Inside the cover, a dark shrine gate (*torii*) in the upper right is surrounded by pine and maple trees, right, while below and left are a brushwood fence and autumn grasses. Bright red maple leaves have fallen. Mist floats in the trees. The base section of the box repeats the mist, maple leaves, and bush clover designs.

A variety of techniques demonstrate the lavish care taken in producing this very special box. The black ground is covered in carefully spaced flat gold particles. Parts of the design elements—the carriage, grasses, crickets and pine tree—are in slight relief. Outlines are either left in reserve in black, or are rendered in gold. The rocks are sprinkled in silver with gold accents, and texture strokes are indicated by gold line. The moon is silver inlay, while the clouds are silver and gold sprinkles with some cut gold and silver squares. Several layers of black lacquer are used for the shrine gate, while a few maple leaves are lacquered brilliant red.

The inkstone itself has a monogram painted in red lacquer, and on the underside an inscription reading, "The purest stone in the universe, Nakamura Chōrokujū." The name refers to a member of the finest inkstone-making family of the period.

Interior of lid

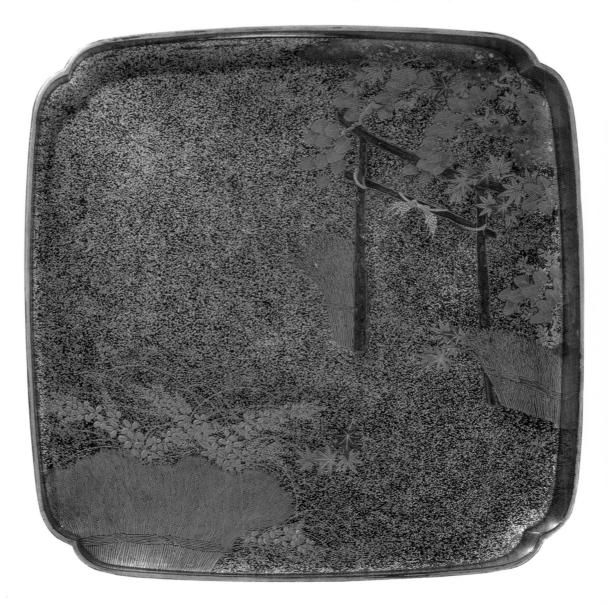

WATER

The earliest representations of water in Japanese art date from the proto-historic, pre-literate periods. In ceramics and bronze "bells" (*dōtaku*) of the Yayoi period (ca. 400 B.C.-A.D. 400), patterns resembling flowing water are found, but their meaning or function is unknown. Perhaps it is no coincidence that water as an artistic motif arose at the same time as wet-rice cultivation. Clay figurines (*haniwa*) and tomb paintings from the Kofun period (ca. A.D. 300-600) often depict boats and water, confirming the importance of navigation to a population newly-arrived from the mainland. Travel by boat from island to island or along rivers and inland waterways was essential.

The earliest Japanese writings, *Kojiki* (compiled 712) and *Nihon shoki* (compiled 720), document the central role of water, particularly the sea, in the formation of myth and belief. The word for ocean, *umi*, is homophonous with the verb "to give birth," and many of the ancient deities (*kami*) were conceived through contact with the sea. In early myths, some gods came from across the ocean, a passage from another world. The boats found in tombs may have "transported" the souls of the deceased to afterlife. Underneath the waves the sea-god lived, later called a "dragon king," with his daughters and female attendants. The legendary first Emperor of Japan, Jimmu, was a close descendant of the great sea-god. The awe commanded by the sea in early poetry reflects these ancient beliefs:

Na kuwashiki	On the offing
Inami no umi no	Of the Inami Sea—
Nakatsu nami	Beautiful its name—
Chie ni kakurinu	Hidden by a thousand
Yamato shimane wa.	lapping waves,
	The Island, Yamato.
Okimi no	Gazing on the channel
Tō no mikado to	Where they ply
Arigayou	Back and forth
Shima to o mireba	To our Lord's distant Court,
Kamiyoshi omoyu.	I think of the age of the gods.

<div align="right">Kakinomoto Hitomaro
Man'yōshū 3:303-304</div>

(Levy, *The Ten Thousand Leaves*, p. 173.)

Official sea travel to the Korean peninsula and the Chinese mainland increased during the Asuka, Nara, and early Heian periods. The journey was always hazardous, and the image of the ocean in art as borrowed from China was of an angry sea populated by odd creatures and saw-toothed fish. Beginning in the Heian period, the residence of the reigning emperor traditionally housed a screen painting of "rough seas" (*araumi*) placed where its ferocious creatures would scare away intruders. Sei Shōnagon describes this screen:

> The sliding screen in the back of the hall in the north-east corner of Seiryō Palace is decorated with paintings of the stormy sea and of the terrifying creatures with long arms and long legs that live there. When the

doors of the Empress's room were open, we could always see this screen. One day we were sitting in the room, laughing at the paintings and remarking how unpleasant they were. (Morris, *The Pillow Book*, vol. 1, p. 15.)

Poetic admiration for the ocean, as found in *Man'yōshū* poetry, is personalized in the early Heian period. The semi-fictional diary, *Tosa nikki*, (ca. 935) describes a journey by boat from the province of Tosa to Kyoto made by its author, Ki no Tsurayuki (868?-945?). Tsurayuki wrote his diary in the guise of a woman, and thereby expressed himself in native (rather than Chinese) poetry. Many of the motifs later associated with water in art can be found in *Tosa nikki*; indeed, it is a *tour-de-force* of water poetry. Strongest among the sentiments inspired by water is longing.

Omoi yaru	It is my heart alone,
Kokoro wa umi o	Filled with distant thoughts of
Wataredomo	them,
Fumi shinakereba.	Which may cross the open sea,
Shirazu ya aruran.	But since a letter cannot walk
	the waves,
	How can they know what I
	would say?

(Miner, *Japanese Poetic Diaries*, p. 67.) Other poems speak both of the perils of the journey (cat. no. 36) and of the beauty of waves that resemble snow or blossoms as they lap against the shore. Long nights spent gazing at the moon prompted Tsurayuki to note:

Miyako nite	This is the very moon
Yama no ha ni mishi	That we see upon the
Tsuki naredo	mountain's rim
Nami yori idete	In the capital
Nami ni koso ire.	But here the moon arises
	from the waves
	And back into the waves it
	sets.

(Miner, *Japanese Poetic Diaries*, p. 74.) Here the observation of the moon setting into the waves is identical to that of the moon setting into the grasses of Musashi Plain (cat. no. 2); thus this poem may be the source (*honka*) for that much later verse.

In Tsurayuki's poems water takes the form of ocean or waves, *nami*. In addition to the affinity between the sea and birth, the word for ocean is, like that for autumn (*aki*), a pun on a verb meaning "to tire of." *Umi* also sounds like *ushi*, "miserable," and *uki*, "to float" or "floating," all words associated with the unhappiness and insubstantiality of life (cat. nos. 27, 35). *Nami* (waves) is often used for *namida*, "tears," which are also suggested by another water word, *tsuyu* or "dew."

A pair of poems in the eleventh-century court tale *Hamamatsu Chūnagon monogatari* shows how these allusions function. The hero, Chūnagon, having crossed the ocean to China, dreams of the love he left behind in Japan. As he tries to comfort her (in his dream) she weeps and writes him this poem:

Dare ni yori	For whom
Namida no umi ni	Have I fallen
Mi o shizume	Into this sea of tears?
Shioruru ama to	Does he know I must wring
Narinu to ka shiru.	my wet sleeve?
	Like a fisherwoman?

His eyes welled up with tears, awaking him.

Hi no moto no	Tonight I saw her
Mitsu no hamamatsu	In my dreams
Koyoi koso	As faithful as the pines
Ware o kōrashi	Waiting on the beach of
Yume ni mietsure.	Mitsu,
	The one who loves me still.

(Rohlich, *A Tale of Eleventh-century Japan*, p. 67.) The "sea of tears" in the first poem sounds like "waves of grief;" furthermore, *ama* for fisherwoman, also means "nun," which the young woman became upon her lover's departure. In the second poem, the place name *Mitsu no hamamatsu* is the source of the story's title. *Hamamatsu* can be read either as "beach pine" or "pining (waiting) on the beach." Countless beach scenes in Japanese art show a row of twisting pines on a jutting spit of land, the visual counterpart to the word in poetry (cat. no. 37).

Rivers, bays, waterfalls, and ponds were depicted in Heian poetry and paintings of famous places (*meisho*). The seasonal aspects of these places, whether natural features or human activities, determined their popularity. Just as Musashi Plain was celebrated for its *murasaki* plants (cat. no. 2), the Tatsuta River (cat. nos. 39, 47) was inseparable from the image of floating, crimson maple leaves, while an iris marsh gave Yatsuhashi its fame (cat. no. 38). Although all such famous place screens have long since been lost, much of the poetry written for them has been preserved in anthologies.

Water motifs in Japanese painting and design generally incorporate a variety of elements which specify season. Floating imagery became extremely popular and examples of chrsyanthemums, plum and cherry blossoms, and maple leaves appear in this catalogue. Plovers or sea gulls along the shore evoke their own poetic associations (cat. nos. 33, 36), as does the unlikely sight of a hare hopping over waves (cat. no. 44). Even man-made objects such as a bridge, fish weirs, and waterwheels could be incorporated into the repertoires of poetry and design, not for their appearance, but for their capacity to identify a famous place or allude to human emotions (cat. nos. 27, 39, 43). Yet if water itself could be said to have a season, then it must be summer with its long rains in the fifth month, or the cooling sounds of a bubbling stream on a hot night in the sixth month. Water designs were appropriately chosen for lightweight summer clothing (cat. nos. 34, 35) or fans.

Designs of water exhibit an imaginative variety of forms: elongated whirlpools (cat. no. 30), zigzag waves (cat. no. 36), and high-pitched breakers (cat. no. 32). One recurring and distinctive motif is the "blue sea wave" pattern (cat. nos. 27, 37, 45, and 49). Its name, *seigaiha*, comes from an ancient court dance adopted from China at an early date. When the dance is performed, the dancers wear costumes with sleeves appropriately decorated with the "blue sea wave" pattern.

For all the beauty of a rippling stream or waves lapping at a pine beach, the very nature of water evokes a Buddhist awareness of the insubstantial course of human existence.

Yo no naka o	To what shall I compare
Nani ni tatoemu	This life?
Asabiraki	The way a boat
Kogi inishi fune no	Rowed out from the morning
Seki naki ga goto.	harbor
	Leaves no traces on the sea.
	Priest Mansei
	Man'yōshū 3:351

(Levy, *The Ten Thousand Leaves*, p. 189.) The opening lines of "An Account of My Hut" (*Hōjōki*), written several centuries later, are all the more poignant, since its author, Kamo no Chōmei (1153-1216), had witnessed the destruction of his beloved capital city, Kyoto, during the battles and natural disasters of the late twelfth century:

The flow of the river is ceaseless and its water is never the same. The bubbles that float in the pools, now vanishing, now forming, are not of long duration: so in the world are man and his dwellings. (Keene, *Anthology of Japanese Literature*, p. 197).

K.L.B.

27.
UJI BRIDGE UNDER THE WILLOWS
Edo Period, seventeenth century
Pair of six-fold screens; colors, gold, and silver on paper
H. 151.3 × W. 327.0 cm., each
Private Collection, Japan

An arched bridge rises into clouds beyond gently swaying summer willows. The silver three-quarter moon suspended in golden clouds at the upper right sets an evening mood. Stylized "blue sea waves" (*seigaiha*) churn under the bridge. Along the banks, the round woven patterns are fish weirs. At lower left, a wooden waterwheel for irrigation diverts the river water. This composition of a bridge and willows (*yanagi bashi*) was exceedingly popular during the Momoyama and early Edo periods, and many examples may be found in American and Japanese collections. Most are nearly identical to the Suntory screens in composition, although earlier examples may show the willows in a progression through four seasons, or include narrative details of rice paddies or river boats.

The locale is Uji, southeast of Kyoto, where, according to tradition, a bridge was built in the seventh century to span the quick-flowing Uji River. The beauty of the sight, with its surrounding green hills and low-lying mists was celebrated in *Man'yōshū* poetry, and was among the earliest Japanese subjects painted on screens. "Uji" sounds like the word *ushi*, "gloom," and this melancholy ring to the place name captured the poetic imagination.

Murasaki Shikibu sets the final ten chapters of *The Tale of Genji* at Uji, and leads the reader there at different times of year. Chapter 45, "The Lady at the Bridge," describes Uji as remote, yet noisy from the sound of waves rushing through the fish weirs. Genji's putative son, Kaoru, comes upon two princesses secluded from the world in Uji, and pays court to the eldest. He looks out upon the river, at "each boatman pursuing his own sad small livelihood at the uncertain mercy of the waters. 'It is the same with all of us,' thought Kaoru . . ." Moved by the scene, he sends a poem to his love:

Hashihime no	Wet are my sleeves
Kokoro o kumite	As the oars work
Takase sasu	These shallows.
Sao no shizuku ni	For my heart knows the heart
Sode zo nurenuru.	Of the Lady at the Bridge.

(Seidensticker, *The Tale of Genji*, pp. 791-792.) In seventeenth-century wood-cut editions of the novel we find illustrations of the bridge, the fish weirs, and the boats for the Uji chapters. Invariably, depictions of Uji Bridge invite the viewer to cross, ascending into clouds. The only reference in *Genji* to anyone traveling on the bridge, (rather than crossing the river by boat) is the arrival of the ill-fated maiden Ukifune. In the final chapter, "The Floating Bridge of Dreams," Ukifune, saved from her attempt to drown herself, renounces her attachments to the world. For Ukifune, the bridge may be seen as a symbol of passage from this to the "other world."

The willows, so prominent here, are alluded to in Chapter 46, "Beneath the Oak," ". . . the willows by the river, their reflections now bowing and now soar-

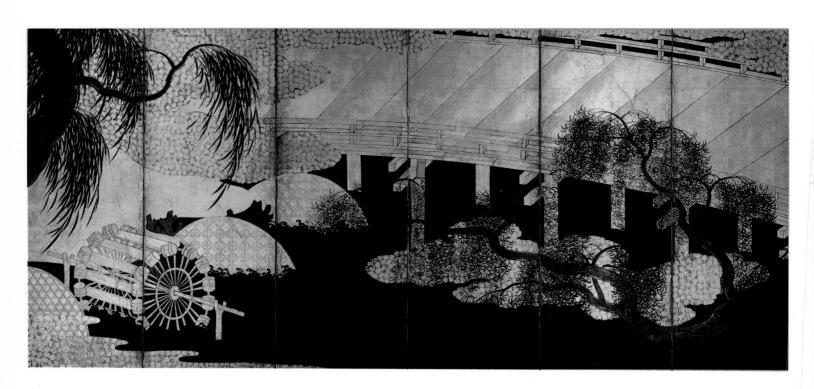

ing as the wind caught them—it was a novel sight for the visitor from the city, and one he was reluctant to leave." The seventeenth-century illustration of this episode includes a lone willow tree. The reference to willows along the river alludes to an old poem, which apparently enjoyed a measure of popularity as a congratulatory verse in Murasaki's day.

Inamushiro	The willows by the river,
Kawa zoi yanagi	They bow,
Mizu yukeba	They soar,
Nabiki okitachi	As the waters pass;
Sono ne wa usezu.	And still their roots are firm.

Emperor Kenzō
Nihon shoki

(Seidensticker, *The Tale of Genji*, pp. 800-801.)

The association with the waterwheel (*mizuguruma*) motif, not found in *Genji*, may be slightly later, as in this poem from the fifth imperial anthology, *Kin'yōshū* (compiled ca. 1124-1127):

Hayaki se ni	The waterwheel
Tatanu bakari zo	Never escapes
Mizuguruma	The churning shallows.
Ware mo ukiyo ni	I too know that
Meguru to o shire.	I turn in a world of grief.

Gyōson (1053-1135)
Kin'yōshū 550

This poem shares Kaoru's sentiments in *Genji*: looking upon the waterwheel, the poet is made aware of the uncertainty of his own existence. The imagery of a "world of grief" (*ukiyo*) has Buddhist origins that, over time, became the basis for the concept of the "floating world" (also *ukiyo* but written with different word-characters), that denotes life in the pleasure quarters of Edo period cities. The early association between the waterwheel and the floating world of grief was expressed in later popular songs (*ko-uta*) such as:

Uji no kawase no	The waterwheel in the
Mizuguruma	Shallows of Uji River—
Nani to ukiyo o	How it turns in this
Megururō.	World of grief.

Kanginshū 64
(Compiled in 1518)

Uji is not the only locale known for waterwheels, willows, and a bridge. In the Edo period, the Yodo River, flowing south from Kyoto, was also renowned for its waterwheel, and the same "floating world" imagery appears in songs about that river. Nonetheless, the stronger associations of Uji with *The Tale of Genji*, fish weirs, and the waterwheel indicate that the subject of these screens is in fact Uji. These screens and their many identical versions are the culmination of representations of Uji Bridge. In them, narrative content is lessened for the sake of emphasizing the design potential of each of the motifs.

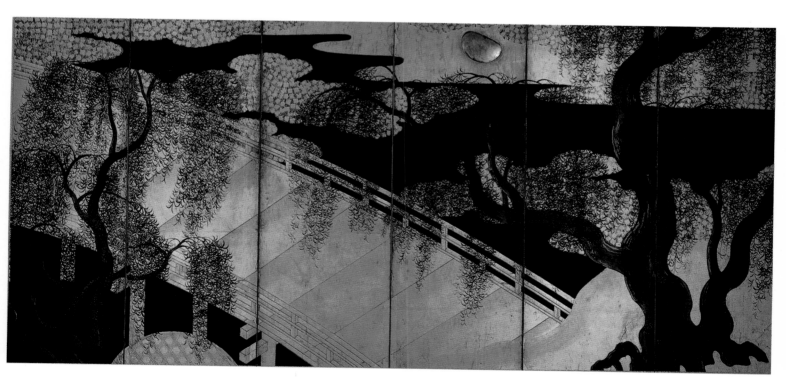

28.
MYTHICAL BIRDS AND PAULOWNIA TREES
Kanō Tan'yū (1602-1674)
Edo Period, mid-seventeenth century
Pair of six-fold screens; colors and gold on paper
H. 176.2 × W. 389.5 cm., each
Suntory Museum of Art

Phoenixes beside a stream and among paulownia compose the subject of this fine pair of screens. The wondrous appearance of the mythical phoenix was considered from antiquity an auspicious omen. During the reign of the Han dynasty sovereign, Hsüan-ti (r. 74-48 B.C.), an Imperial memorial reported:

> Male and female phoenixes have perched and sweet dew has descended in the capital, so that auspicious presages have appeared simultaneously. We . . . have prayed that the people may receive blessings and happiness. Young phoenixes have flown to observe and to fly back and forth . . . supernatural brilliances appeared and shone . . . (Dubs, *The History of the Former Han Dynasty*, vol. 2, pp. 244-245.)

In this account, phoenixes were viewed as heaven's accolade for good government. To the Chinese, the birds were also symbols of the south, summer, the sun, and of the male principle of *yang*.

These connotations were carried over to Japan as well, but the nature of the phoenix remained essentially Chinese. Paulownia trees, where the bird is said to nest, were known in Japan both for their leaves and for their early summer purple flowers.

> The purple blossoms of the paulownia are also delightful. I confess that I do not like the appearance of its wide leaves when they open up But I cannot speak of the paulownia as I do of the other trees; for this is where that grandiose and famous bird of China makes its nest, and the idea fills me with awe. (Sei Shōnagon in Morris, *The Pillow Book*, vol. 1, p. 43.)

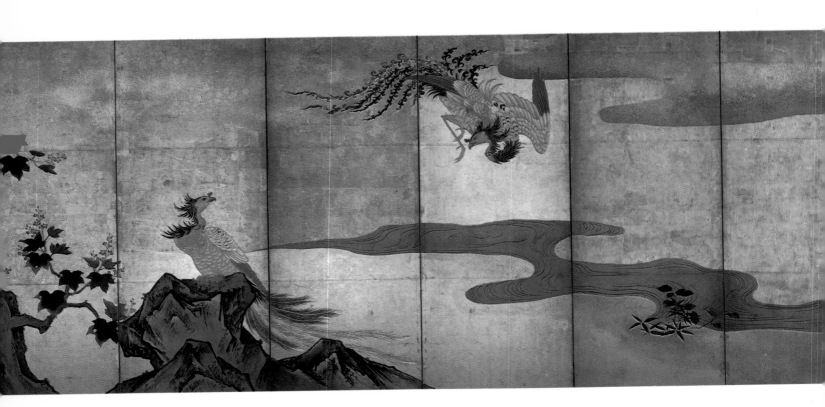

Both the flowing stream that connects the two screens and the layered gold clouds give imaginary depth to the scene. Rather than applying an overall gold-leaf ground, the artist has varied his techniques to include silver and gold dust sprinkled over plain ground in some areas, and different sizes of cut gold and silver flakes in others. This subtle texturing and the changing reflective qualities of the gold heighten the illusion of shimmering depth and space. Only the stream, meandering along golden banks, is left uncolored and undecorated. Its ripples are painted in long curving shades of black ink on plain ground.

Although the birds are mythical, details of their feathers and feet, differences in coloring, and the style of their tails show the artist's concern for naturalistic representation. Ink texturing in the rocks and tree trunks are characteristic Kanō school techniques, derived ultimately from Chinese models.

The artist, Kanō Tan'yū, served the Tokugawa ruling family as their official painter. The auspicious subject matter of this pair of screens may indicate that they were painted to commemorate an important marriage. Tan'yū traveled often between Edo and Kyoto directing major artistic projects in the two cities. Last in the line of the great Kanō masters, he reorganized the workshop system and established a style that was emulated through the nineteenth century. Each of the screens bears the signature "painted by Tan'yū *hōgen*" and the gourd-shaped Shushin seal. Tan'yū received the honorary *hōgen* rank in 1638, and held it until 1662.

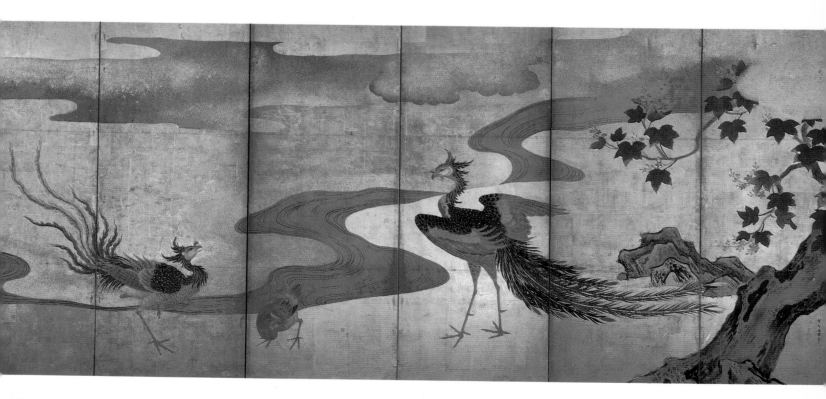

29.
NŌ ROBE (NUIHAKU TYPE) WITH DESIGN OF "CHRYSANTHEMUM STREAM"
Edo Period
Embroidery and metallic foil (*nuihaku*) on figured satin
H. 144.5 cm.
Suntory Museum of Art

Chrysanthemums in full bloom with their leaves are carried along a flowing stream, partly hidden behind clouds that were once richly appliquéd in gold foil. Unlike the melancholy suggested by the autumn grass designs (cat. nos. 5, 6), this Nō robe's decoration is auspicious. The motif, found on mirrors of the Heian period, derives from the belief that chrysanthemum-scented water or wine confers immortality. Chrysanthemums, unlike other autumn flowers, are themselves long-lasting. As its cultivation and appreciation spread during the Edo period, the chrysanthemum became ever more prominent in design.

Gold thread defines the outlines of the white, deep purple, blue, and red satin stitch flowers as well as the leaf veins. The chrysanthemum motif is also repeated in the fabric's figured ground, where it embellishes a woven design of interlocked T-frets. The richness of this costume would have been enhanced by the clouds, whose shimmering gold foil has since worn away.

Detail

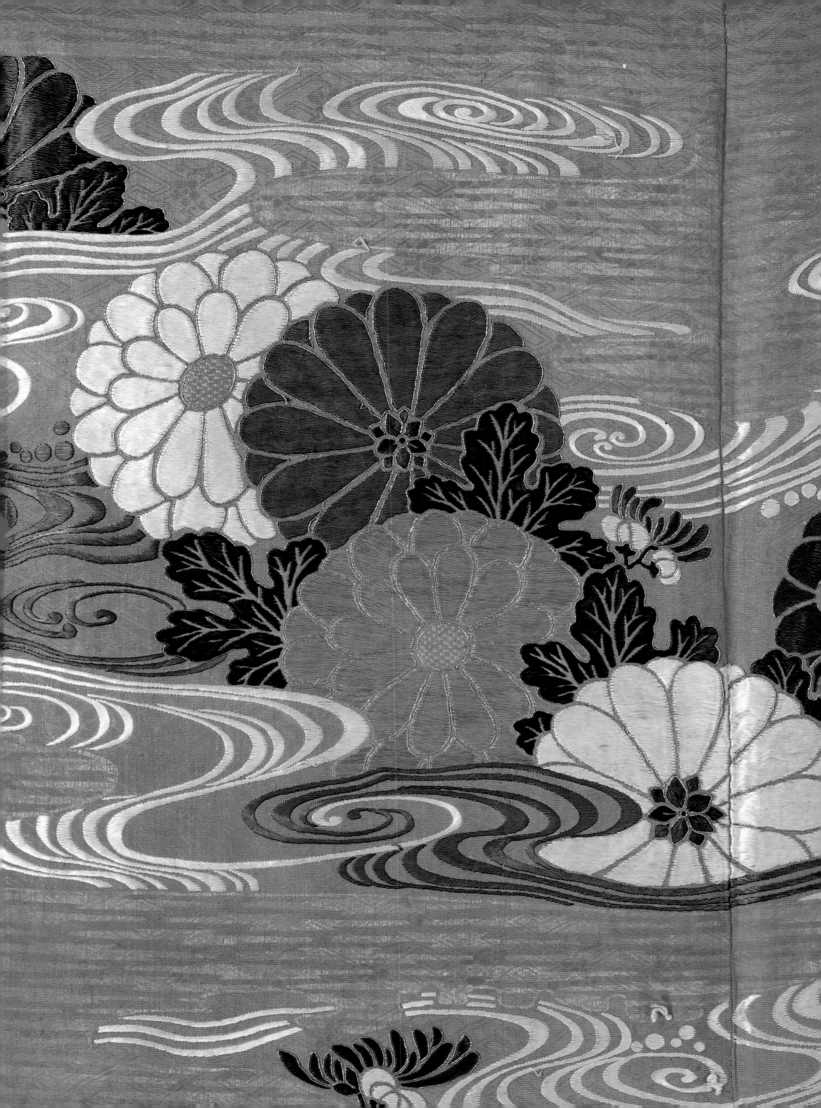

30.
NŌ ROBE (*SURIHAKU* TYPE) WITH DESIGN OF "KANZE STREAM"
Edo Period
Metallic foil (*surihaku*) on figured silk
H. 137.0 cm.
Eisei Bunko Foundation

Stylized whirlpools in alternating gold and silver bands extend across the upper half and sleeves of this deep blue-figured satin robe. The silver appliqué has tarnished over time leaving the gold much brighter.

This distinctive wave pattern derives from the well-known crest of the Kanze school of Nō actors, which traces its ancestry to Kan'ami (d. 1384), advisor to the shogun Ashikaga Yoshimitsu (1358-1408) and the author of several plays. This wave pattern is found on numerous Nō costumes, and was utilized by Hon'ami Kōetsu (1558-1637) and Tawaraya Sōtatsu (active ca. 1602-1640) in Nō songbook covers designed for the Kanze school (see cat. no. 3).

Surihaku denotes both the technique of applying metallic foil designs to silk, and this type of lightweight inner robe worn in Nō by actors of female roles. Only the neckline of *surihaku* is seen when worn, unless the outer robe or robes have been draped off the shoulders. The designs on this type of robe are therefore often abbreviated from the waist down, and the great majority are done in repeating patterns such as the "Kanze stream" seen here.

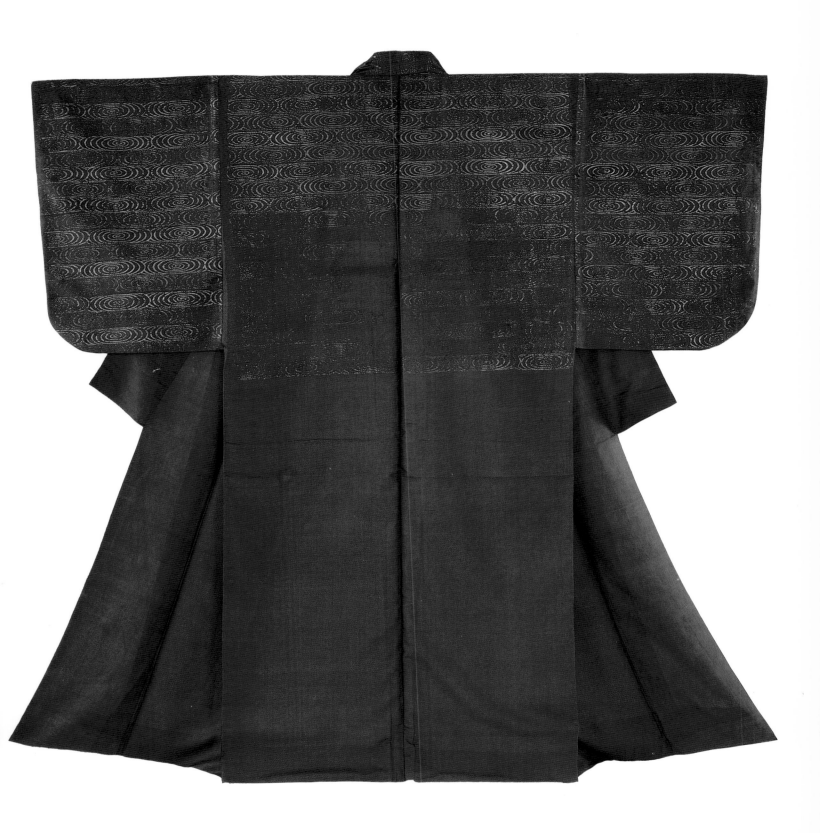

31.
NŌ ROBE (*MAIGOROMO*) WITH DESIGN
OF FLOWER RAFTS
Edo Period
Plain weave gauze with design woven in gold thread
H. 164.0 cm.
Eisei Bunko Foundation

Cherry blossoms and maple leaves, the favorite paired motifs of spring and autumn, float on wooden rafts down a flowing stream. The simple repeated design in gold thread creates a contrast between thin horizontal lines of water, and the thick diagonals of the rafts. An outer garment worn by an actor of a female role, this soft robe would be lovely when worn during slow graceful dance movements.

The imagery of flower rafts (*hana-ikada*) was quite popular in the Momoyama and Edo periods. It appears in lacquer at the Kōdai-ji mausoleum (cat. no. 12) and in ceramics (cat. no. 46) as well as textiles. The designs are often literal renderings of a poetic image of cherry blossoms or maple leaves that cluster together as they float downstream, giving the illusion of a raft made of flowers. A popular song (*ko-uta*) plays with this theme:

Yoshino no kawa no	Flower rafts
Hana ikada	Floating on the
Ukarete	Yoshino River
Kogaresoro yo no,	Row on, row on
Kogaresoro yo no.	My heart's on fire.

Kanginshū 145

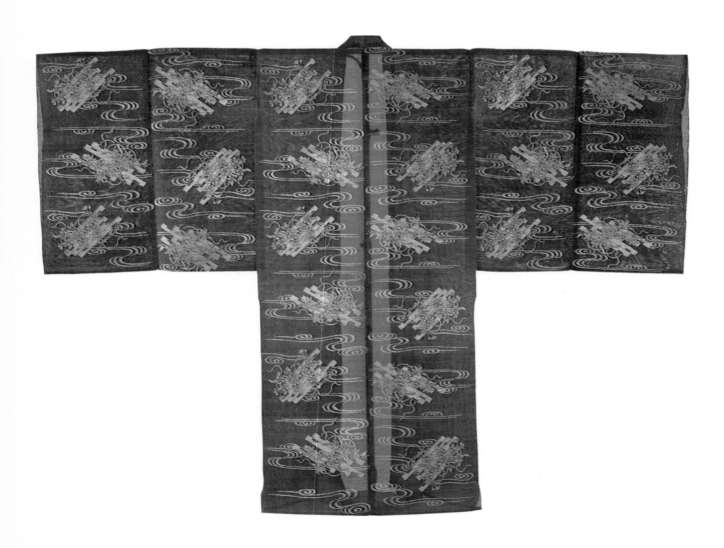

32.
KYŌGEN COSTUME (*KATAGINU* TYPE)
WITH WAVE DESIGN
Edo Period
Stencil-dyed hemp with shell-white (*gofun*)
H. 64.0 cm.
Private Collection, Japan

The frayed edges along the bottom of this sleeveless vest indicate that it may originally have been the upper half of a *nagakamishimo*, a garment that combines vest and pants. A pattern of seething white-capped waves covers the entire vest. Undulating lines of varying thickness alternate with curls and dots of spray. The theme of "rough seas" (*araumi*, see p. 80.) as a design motif can be traced to T'ang (618-906) China, and early examples often included ferocious sea creatures rising from the waves. The design of this vest, in contrast, exploits the rhythmical cadences of the waves alone for maximum decorative effect.

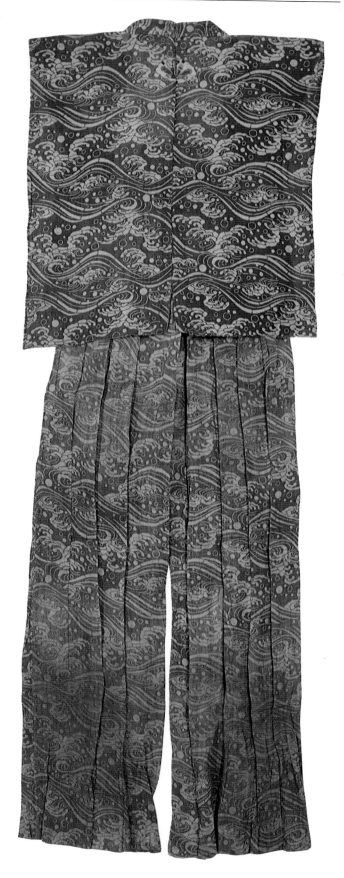

33.
KYŌGEN COSTUME (*KATAGINU* TYPE) WITH DESIGN OF PLOVERS AND WAVES
Edo Period
Stencil-dyed hemp with shell-white (*gofun*)
H. 83.1 cm.
Eisei Bunko Foundation

White waves and plovers raised in shell-white add texture to the brown hemp ground. Black ink line further defines the birds, whose wings are also tinged with green. In this *kataginu*, the animated movements of the birds together with the dazzling wave crests give the design a sprightly feeling appropriate for the world of Kyōgen.

In poetry, the dominant image of plovers since the *Man'yōshū* is the sad sound of their cry.

Ou no umi no	Plover on the river bank
Kawara no chidori	Where it flows into the Ou Sea
Naga nakeba	When you cry
Waga sahogawa no	So my heart turns
Omōyurakuni.	To the Saho River, my home.

<div align="right">

Prince Kadobe
Manyōshū 3:371

</div>

(Levy, *The Ten Thousand Leaves*, p. 196.) This association is still expressed in this Kyōgen song, "Plovers on the Beach:"

Hama chidori no	The voices of plovers
Tomo yobu koe wa	Calling to their mates
Chiri chiri ya,	Seem to be saying,
Chiri chiri ya,	"Chiri chiri ya"
Chiri chiri to	"Chiri chiri ya"
Tomo yobu tokoro ni.	"Chiri chiri ya."

<div align="right">

Kyōgen kayō 126

</div>

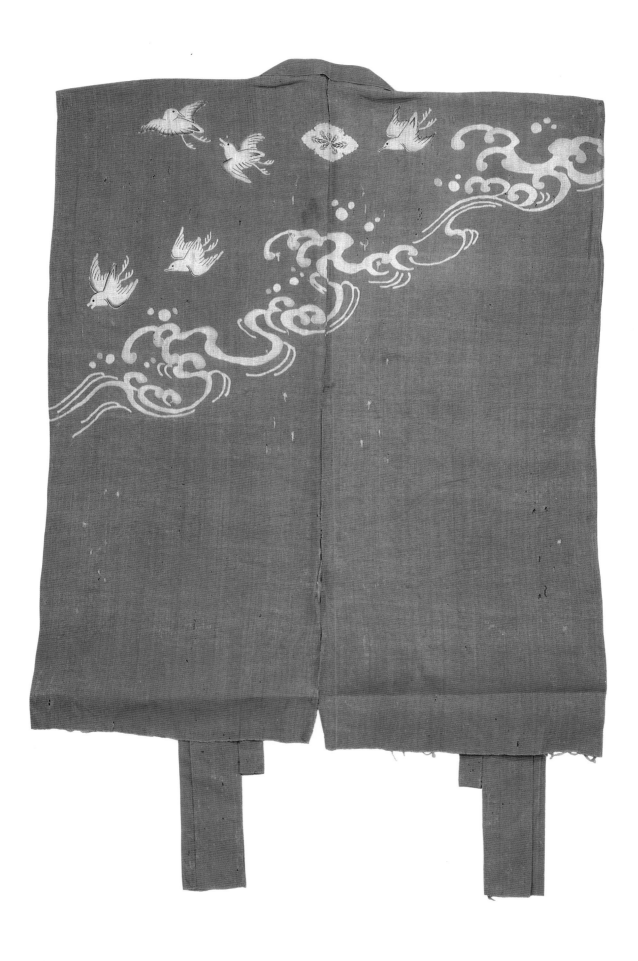

93

34.
ROBE (*KOSODE*) WITH DESIGN OF FLOWER BOUQUETS IN FLOWING WATER
Edo Period
Embroidery and stencil dyeing on figured silk gauze
H. 167.0 cm.
Suntory Museum of Art

*K*osode denotes the "small-sleeved" robe that, although derived from Heian period court dress, has been the principal garment of Japanese dress since the fifteenth century. Underneath many layers of stiff robes with long, loose sleeves open at the wrists were thinner undergarments, cut to smaller sizes. These were *kosode*, whose short sleeve lengths and smaller wrist openings contrasted with the *ōsode*, or "large-sleeved" robes.

During the Kamakura and Muromachi periods, *kosode* emerged as the standard outer garment among commoners and the aristocracy alike. Women wore *kosode* tied at the waist with a sash (*obi*), while men adopted the garment to be worn with full-skirted trousers (*hakama*). The designs gradually evolved from plain or twill-weave silk to elaborate robes combining the latest techniques and designs. The Edo period saw the culmination of this development (cat. no. 50).

This *kosode* features an unseasonable combination of spring, summer, and autumn flowers, calling to mind a poem by Ise no Tayū (987?-1063?), "composed when someone sent me a robe woven with a pattern of mingled plum blossoms and chrysanthemums."

Kiku wa aki	Although I thought
Ume wa haru to zo	The chrysanthemum was for
Omoishi o	autumn
Onaji ori ni mo	And the plum for spring
Niou hana kana.	Now I see that they are flowers
	Which bloom together in a
	single season.

The poem contains a pun in the fourth line: *ori* means "woven fabric" as well as "season." Thus the last two lines can also read, "Now I can see that they are flowers/ that bloom together in one woven pattern." (Brower and Miner, *Japanese Court Poetry*, p. 172.)

This thin summer *kosode* celebrates the flower and water theme. Pale blue-dyed gauze is figured with a design of cherry blossoms, chrysanthemums, peonies, and bush clover floating in clusters on gently rippled waters. Iris bouquets, peonies, chrysanthemums and cherry blossoms tossing amid high waves and scattered rocks, all done in stencil-dyeing and embroidery, compose the lower half of the robe. White waves form a distinctive border along the hem. The strong pictorial composition and varied use of techniques make this *kosode* a fine example of Edo design.

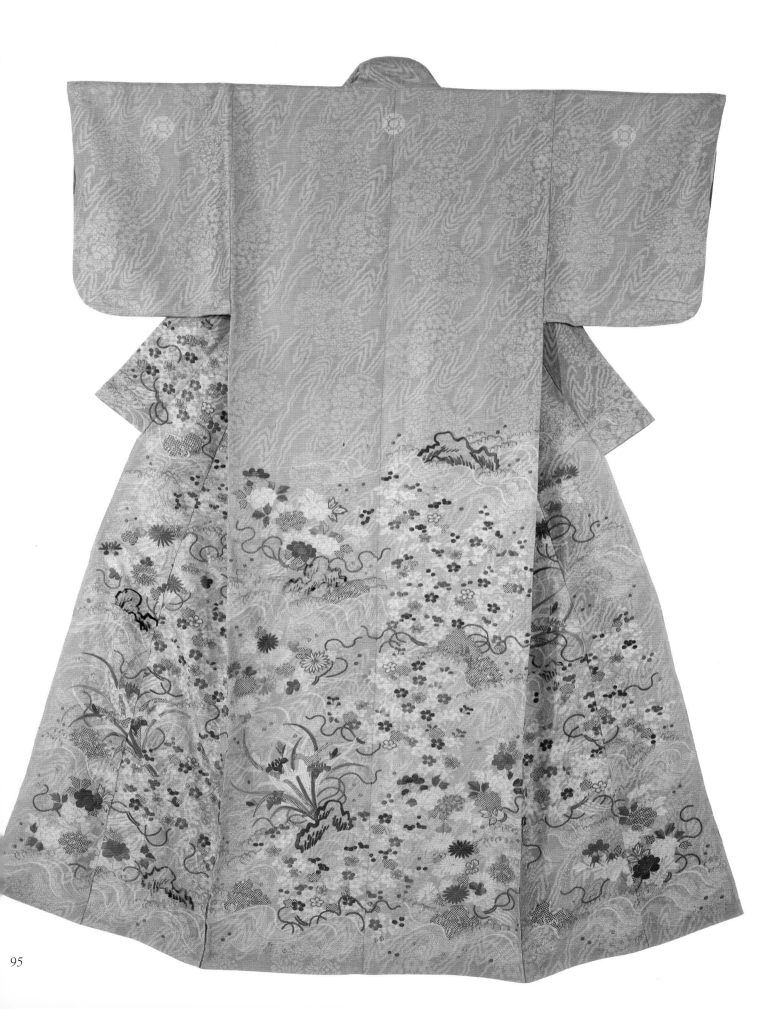

35.
ROBE (*KOSODE*) WITH DESIGN OF BANANA PLANT IN RAIN
Edo Period
Emboidery and stencil dyeing on white silk crepe
H. 170.0 cm.
Suntory Museum of Art

Banana plants growing among rocks create a striking composition. The plant groupings recede in scale from the lower right hem, while a leitmotif of bamboo grass and dots of earth help to define the imaginary ground. A stream weaves among the banana plants, fed by the waters of a driving rain whose lines introduce a jarring overall diagonal pattern. The stream, dots of earth, and rain are stencil-dyed in shades of blue, as are some of the rocks, bamboo grass and banana leaves. Details are accented in embroidery with gold, green, ochre, and magenta threads.

The sound of banana leaves (*bashōba*) blowing in the wind resembles that of a gentle rain. Because the leaves tear easily and hang in shreds after a rainstorm, the banana plant was not cultivated in private aristocratic gardens. However unsightly, the plant nonetheless had appeal. Indeed, it was often a metaphor in Buddhist scriptures and poetry: like the trunk-less banana plant, human reality was also unsubstantial.

Kaze fukeba	When the wind blows
Ada ni yareyuku	The banana leaves tear
Bashōba no	In shreds.
Areba to mi o mo	Can one rely
Tanomubeki ka wa.	On such a body?

<div align="right">Saigyō
Sankashū 1028</div>

In the late seventeenth century, the haiku poet Matsuo Bashō (1644-1694) planted a banana plant in his garden, and thereby received his *nom de plume*, Bashō, "Master Banana Plant." His poetry often alludes to the sounds of leaves rustling in the rain:

Bashō nowaki shite	The banana in the autumn
Tarai ni ame o	blast—
Kiku yo kana.	The night I hear
	Rain [dripping] in a tub.

(Shively, "Bashō—the Man and the Plant," p. 152.)

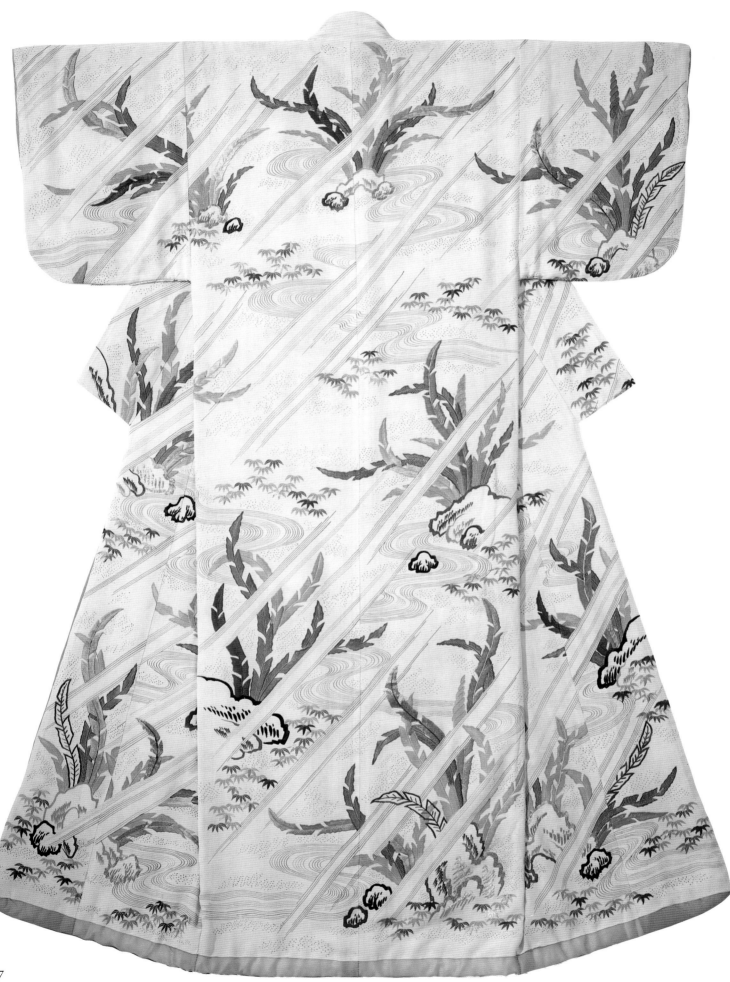

36.
MIRROR BOX (*KAGAMIBAKO*) WITH DESIGN OF PLOVERS AND WAVES
Muromachi period
Black lacquer on wood with gold *maki-e*
H. 4.0 × D. 13.0 cm.
Suntory Museum of Art

This small, round box once contained a mirror, and was part of a toiletry case set (cat. no. 9). The cover is dotted with plovers, some circling over waves, others alighting on a beach. The inside of the base is decorated with the zigzag crests of waves.

Plovers (*chidori*) darting among waves is an ancient motif (cat. no. 33). Their light-hearted appearance belies the sadness that is heard in their cry. Several lacquer objects of the Muromachi period were designed with the plover motif to accompany the concealed script of the following poem:

Shio no yama	Plovers perched on
Sashide no iso ni	The jutting rocks
Sumu chidori	Below Mt. Shio
Kimi ga miyo oba	Cry out:
Yachiyo to zo naku.	May our Lord live forever!

<div align="right">

Anonymous
Kokinshū 7:345

</div>

The congratulatory tone of this verse contrasts with the usual melancholy associations of the plover's cry.

The high-pitched waves of the interior are especially appropriate for a mirror box, since water and mirrors are both reflective. From ancient times, mirrors were symbols of rank and could facilitate communication with the gods. A passage by Ki no Tsurayuki in his *Tosa Diary* (see p. 80) describes the offering of a precious mirror to the deity of Sumiyoshi Shrine who had disrupted Tsurayuki's sea journey:

Chihayaburu	Mighty he is,
Kami no kokoro	The god whose heart was
Aruru umi ni	raging
Kagami o irete	With the wild sea,
Katsu mitsuru kana.	Yet when we gave the mirror to the waves, They and his heart reflected calm.

(Miner, *Japanese Poetic Diaries*, p. 84.) The practice of tossing a mirror into waters has been confirmed with the discovery of mirrors along the banks of many lakes and rivers. The association between mirrors and divinity was not limited to native *kami*. Mirrors of the Heian and later periods have been found inside Buddhist sculptures, buried with Buddhist scriptures, and deposited in Buddhist temples. The most remarkable examples are the more than 3000 mirrors deposited in the West Circular Hall (Saiendō) of Hōryū-ji, some inscribed with dedicatory vows and prayers.

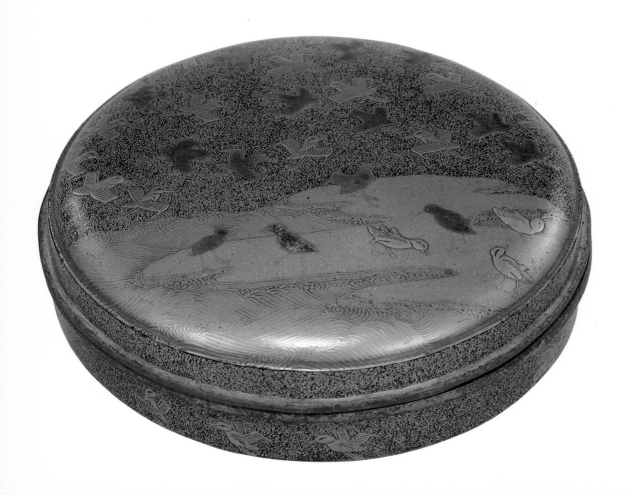

Detail of interior of base

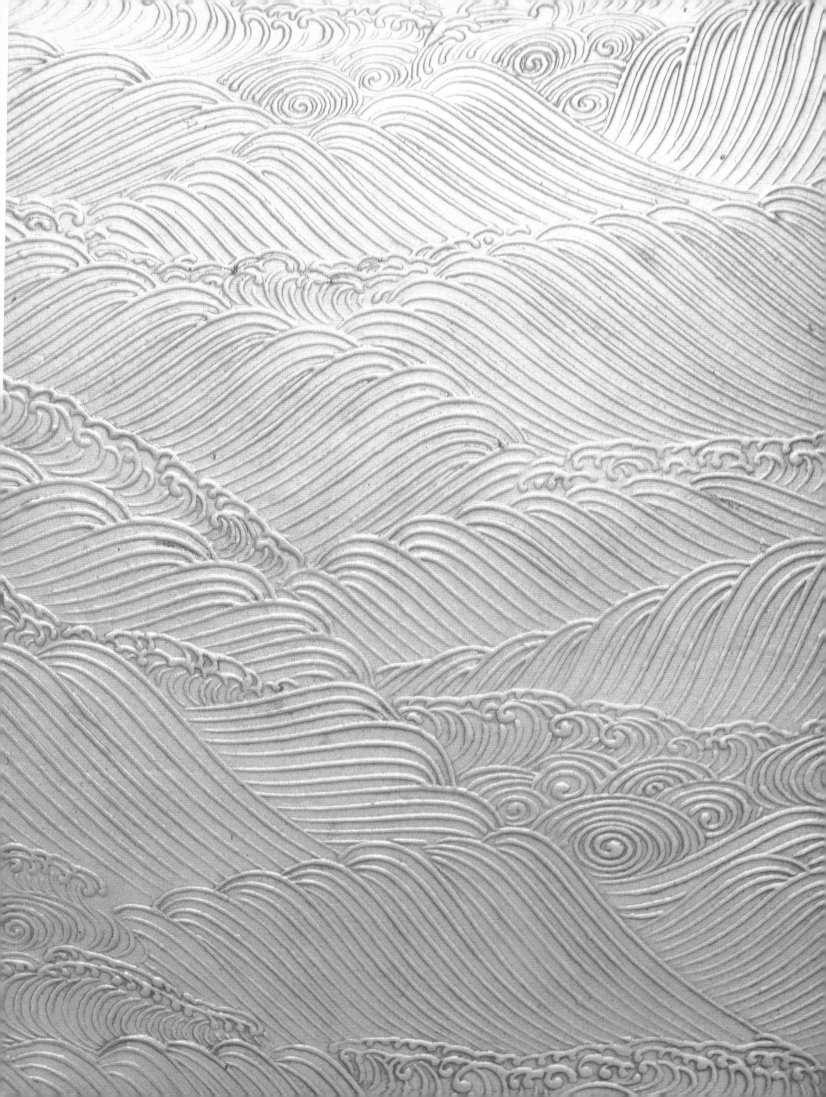

37.
INKSTONE CASE (SUZURIBAKO) WITH DESIGN OF SCROLLS AMID WAVES
Momoyama period, late sixteenth century
Black lacquer on wood with gold *maki-e*
H. 5.2 × W. 22.1 × L. 24.3 cm.
Suntory Museum of Art

Against a background of "blue sea waves" (*seigaiha*) pattern, stylized pine and cherry trees rise from land spits on the exterior of this inkstone case. A thatched dwelling on the shore overlooks the sea as sea gulls dart among rocks, shells, and grasses. Decorated scrolls, or bolts of cloth, float in the waves. The interior of the lid is far simpler: a single cherry tree amid calm waters with one rolled and one open scroll is set against a black ground. A branch of cherry blossoms decorates each of the two brush compartments in the base.

The theme of this inkstone case awaits precise identification. It may relate to the "assembled treasures" (*takara zukushi*) motif, which shows illustrated scrolls or rolls of rich brocade drifting in the sea together with symbols of good fortune and longevity. In spite of its complexity of design, this inkstone case is related to the Kōdai-ji type in technique (cat. no. 12).

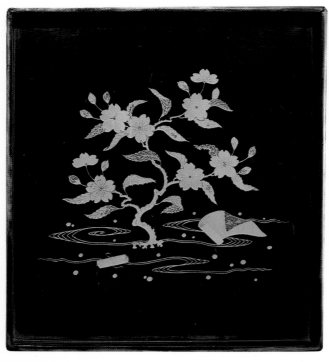

Interior of lid

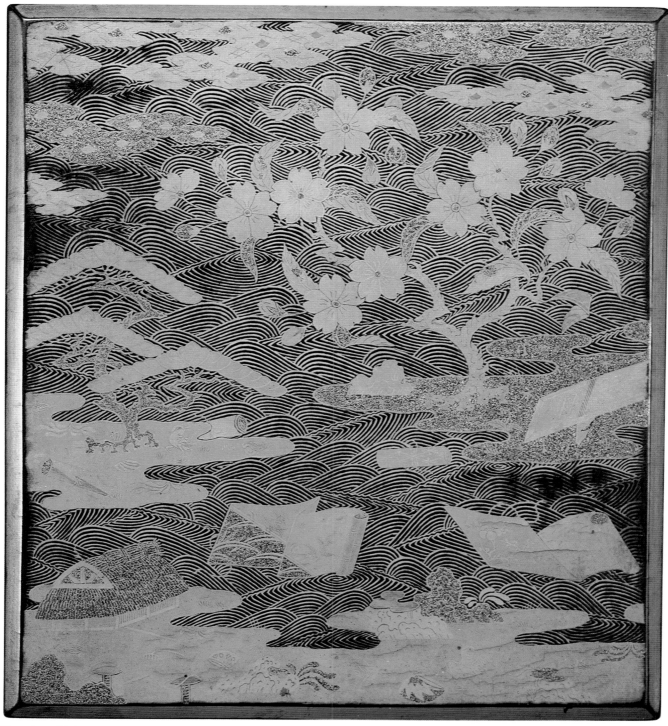

Exterior of lid

38.
INKSTONE CASE (SUZURIBAKO) WITH DESIGN OF IRIS MARSH AT YATSUHASHI
Late Momoyama-early Edo periods
Black lacquer on wood with gold *maki-e*
H. 3.6 × W. 16.8 × L. 18.2 cm.
Suntory Museum of Art

The designs of this inkstone case have specific poetic references, a feature usually associated with earlier lacquerware. The iris marsh on the lid alludes to a scene from the tenth-century *Tales of Ise*, while inside the lid, a willow tree beside a stream refers to a famous poem by the poet-priest Saigyō (1118-1190). Both themes were later adapted into the Nō plays "The Iris" (*Kakitsubata*) and "The Willow Pilgrimage" (*Yugyō yanagi*).

The iris motif derives from the ninth episode in *Ise*, when "a certain man" (Ariwara no Narihira), and his friends left the capital for the east. They stopped to rest at a place called Yatsuhashi ("Eight Bridges") in Mikawa province. "Someone glanced at the clumps of irises that were blooming luxuriantly in the swamp. 'Compose a poem on the subject, "A Traveler's Sentiments," beginning each line with a syllable from the word iris [*kakitsubata*],' he said. The man recited:

Karagoromo	I have a beloved wife,
Kitsutsu narenishi	Familiar as the skirt
Tsuma shi areba	Of a well-worn robe,
Harubaru kinuru	And so this distant journeying
Tabi o shi zo omou.	Fills my heart with grief."

(McCullough, *Tales of Ise*, pp. 74-75.) When the author of *Sarashina Diary* (cat. no. 2) visited the locale in 1020, she found that the iris marsh had dried up. "Next we passed a village called Yatsuhashi, but it was a dull place and there was no trace of the bridges except in the name." (Morris, *As I Crossed a Bridge of Dreams*, p. 51.)

Inside the lid, the trunk of the willow tree conceals the Chinese character for shade (*kage*). Including the text of poems within paintings was a Heian period custom. Chinese characters or *kana* script could be read within a painting to enhance its significance. In this inkstone case, the single character provides the clue to the scene's poetic origin.

Michinobe no	"Just a brief stop"
Shimizu nagaruru	I said when stepping off the
Yanagi kage	road
Shibashi tote koso	Into a willow's shade
Tachidomaritsure.	Where a bubbling stream flows by . . .
	As has time since my "brief stop" began.

Shinkokinshū 3:262

(LaFleur, *Mirror for the Moon*, p. 78.)

Sophisticated techniques often distinguish lacquerware that feature such pictorial themes, in contrast with the simplicity of the more decorative Kōdai-ji wares. This inkstone case displays a combination of flat and relief designs, "polished-out" designs, silver inlay and scattered cut gold and silver squares, against *nashi-ji* ground.

Interior of base

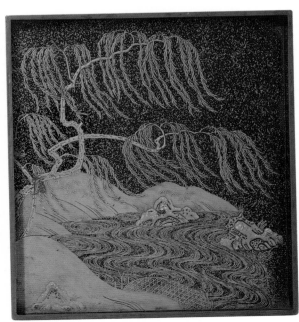

Interior of lid

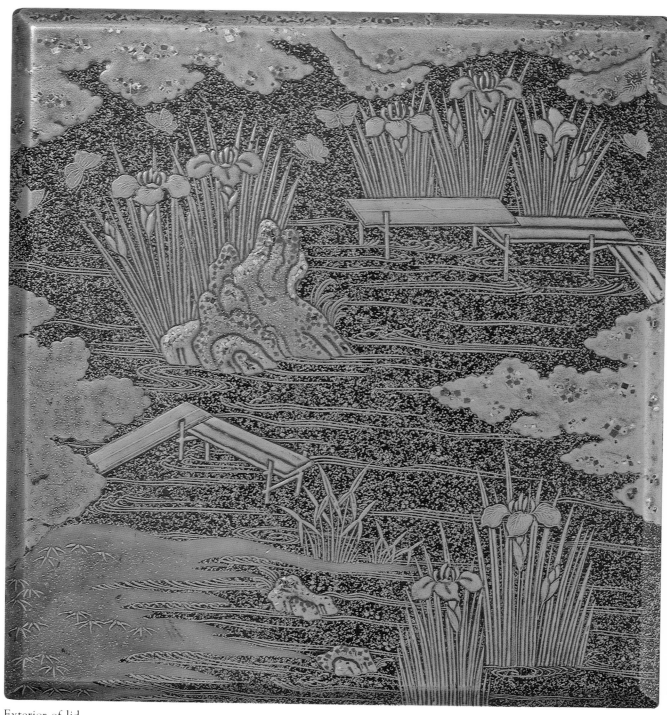

Exterior of lid

39.
INCENSE PILLOW (KŌMAKURA) WITH OPENWORK
DESIGN OF WHIRLPOOLS AND WHEEL
Momoyama period
Black lacquer on wood with gold *maki-e*;
cloisonné drawer pull
H. 13.0 × W. 24.5 × L. 11.5 cm.
Suntory Museum of Art

This openwork rectangular box with drawer origi-
nally contained an incense burner for perfuming a
woman's hair (cat. no. 23). Maple leaves in gold and
red *nashi-ji* float along a stream. The openwork on the
top represents an ox-cart wheel (*katawaguruma*) half
submerged in water, while the openwork spirals on the
sides represent whirlpools.

The motif of maple leaves floating in waters (cat.
nos. 21, 47) usually alludes to the Tatsuta River. Famous
in classical poetry as a place for viewing autumn leaves,
the site was familiar to travelers to the Nara region.
A poem composed at Tatsuta River by Ariwara no
Narihira describing the maple leaves fallen in the river
was but one of many.

Chihayaburu	Unheard of
Kamiyo mo kikazu	Even in the age
Tatsutagawa	Of the Mighty Gods—
Karakurenai ni	These deep splashes
Mizu kukuru to wa.	Dyed in Tatsuta's waters.

(McCullough, *Tales of Ise*, p. 141). In *Tales of Ise* this
poem is said to have been composed at the spot; how-
ever in *Kokinshū* (5:294) the same poem is recorded as
having been written for a screen painting depicting
the Tatsuta River. A second poem was also composed
for the same screen.

Momijiba no	At the river mouth
Nagarete tomaru	Where these floating
Minato ni wa	Red leaves gather,
Kurenai fukaki	Perhaps the waves break
Nami ya tatsuran.	In deep crimson.

<div align="right">

Sosei
Kokinshū 5:293
</div>

These poems were probably inscribed on decorated
poem-papers (*shikishi*) and affixed to a screen painting
that included the Tatsuta River scene among other sea-
sonal subjects.

40.
**COMB BOX (*KUSHIBAKO*) WITH DESIGN
OF PLUM BLOSSOMS AND STREAM**
Edo period
Black lacquer on wood with gold *maki-e*
H. 13.1 × W. 13.8 × L. 16.7 cm.
Suntory Museum of Art

A simple yet effective design of five-petal plum blossoms floating in a stream adorns the top and sides of this comb box. This particular shape, like that of the toiletry case (cat. no. 9), changed little after the thirteenth century. The overlapping lid is cut out on the sides for the metal rings and cord. A set of twenty or more combs could be accommodated within.

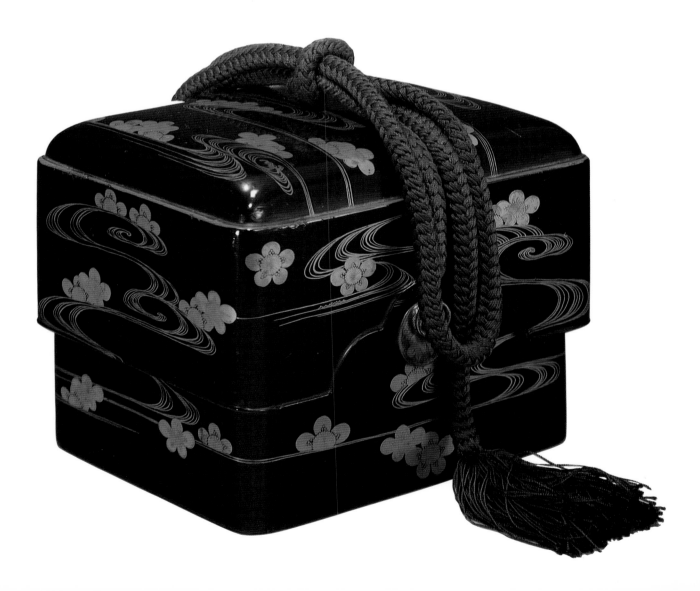

41.
LARGE TRAY WITH DESIGN
OF WATER PLANTAIN AND STREAM
Edo period
Black lacquer on wood with gold _maki-e_
H. 9.3 × W. 58.0 × L. 55.0 cm.
Suntory Museum of Art

This large tray would have been used to present gifts of clothing or to receive folded garments.

Water plantain (J. _omodaka_, L. _Alisma Plantago-aquatica orientale_) grows along the edges of streams or wet-rice fields. Its long leaves are shaped like arrowheads, while the long-stemmed white flowers blossom in midsummer. The Japanese name for the plant is a pun which greatly amused Sei Shōnagon. "I like the water-plantain and, when I hear its name, I am amused to think that it must have a swollen head [pompous]" (Morris, _The Pillow Book_, vol. 1, p. 60.) With such an odd name, poets had little use for the plant, but its depiction in lacquer and textiles began in the Heian period.

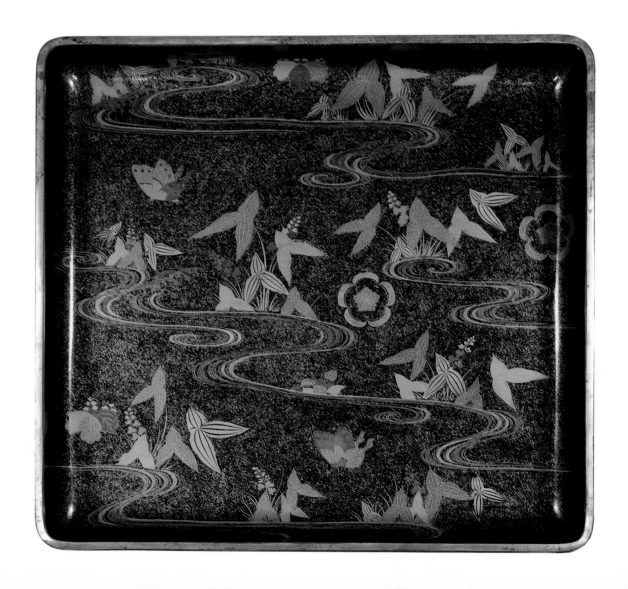

42.
SPOUTED HOT WATER VESSEL (YUTŌ) WITH DESIGN OF TORTOISES AND WAVES
Edo period, seventeenth century
Black lacquer on wood with gold *maki-e*; gilt-bronze
fittings
H. 24.5 × D. 24.3 cm.
Suntory Museum of Art

Two ferocious tortoises emerge from the waters flanking the spout of this water vessel. On the lid, a "mother and child" tortoise swim along on their backs.

This three-footed cylindrical vessel is bold in form and design. Flat gold is used for the most part, while nashi-ji defines the patterns on the tortoises' shells. The design on the handle is the so-called "foreigner's scrollwork" (namban karakusa, cat. no. 21). Dense gold outlines the rim of the spout and red lacquer colors the interior.

In ancient China the tortoise was associated with the north, and became a symbol of longevity. These connotations were adopted in Japan, and tortoise designs appear on Heian mirrors, along with cranes, bamboo and pine, motifs equally auspicious in their connotations. These animals earned the nickname *minogame*, "straw coat tortoise," because their shells often have a kind of parasitic growth that looks like a peasant's straw raincoat. These are the hairy tails of the tortoises seen on this vessel.

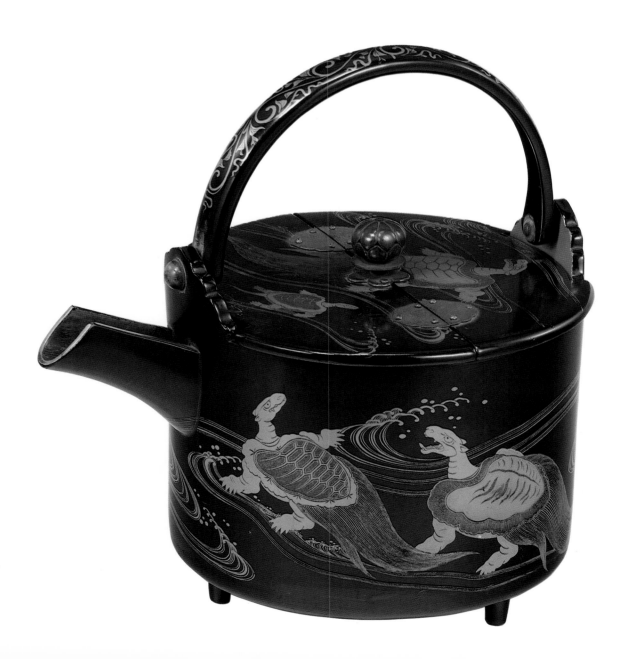

43.
**TIERED FOOD BOX (JŪBAKO) WITH DESIGN
OF HYDRANGEA AND BRIDGE OVER RUSHING WATERS**
Edo period
Black lacquer on wood with gold *maki-e*, mother-of-pearl inlay
H. 25.0 × W. 22.5 × L. 20.5 cm.
Suntory Museum of Art

The four sides and top of this tiered food box show a continuous design of hydrangea blossoms and their insect-eaten leaves, growing before rapidly flowing water and a high-arched bridge. Viewed flat, as four consecutive panels, the design recalls compositions of the Uji Bridge (cat. no. 27). Beyond the hydrangea, billowing waves rush under the bridge giving the stylized design a dramatic sense of depth.

The primary technique of this *jūbako* is flat gold *maki-e* on black ground. Red-tinged gold particles are sprinkled along the bridge, and the veins of some leaves are drawn in red. Mother-of-pearl inlay for the blossoms further enlivens the surface of this remarkable piece.

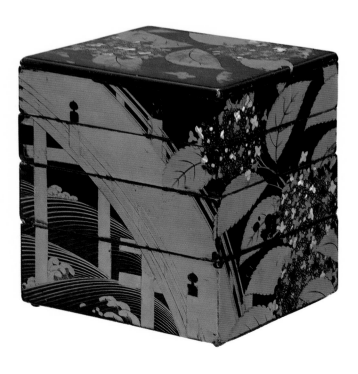

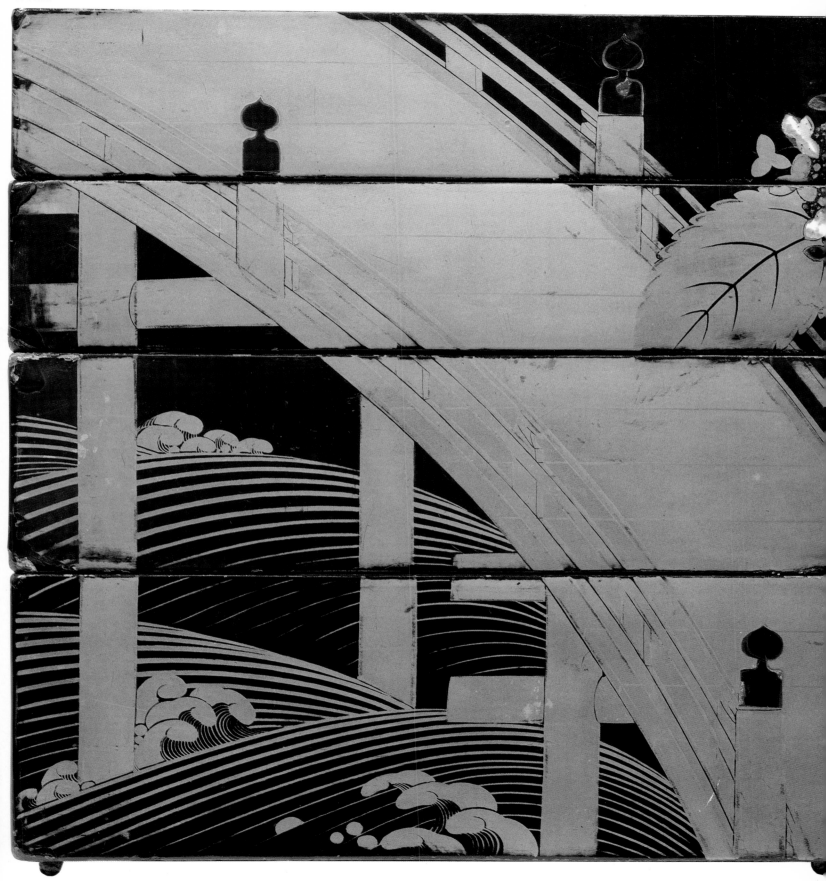

44.
SET OF FIVE TRAYS WITH WATER AND
OTHER DESIGNS
Edo period
Black and colored lacquer on wood
H. 4.0 x D. 36.1 cm., each
Suntory Museum of Art

This set of five trays contains two which incorporate the hare and water motif. Chinese legend holds that a hare lives on the moon, mixing an elixer of immortality, while an early Japanese tale recounts how a clever hare attempted to trick crocodiles into forming a bridge by which to cross the ocean. This design motif owes its popularity to a line in the Nō play *Chikubushima* (an island on Lake Biwa):

Tsuki umi no	The moon, floating
Ue ni ukande wa	Above the ocean—
Usagi mo	Do hare also
Nami o hashiru ka.	run over the waves there?

The poet and painter Yosa Buson (1716-1783) captured this imagery:

Meigetsu ya	The bright moon
Usagi no wataru	The lake of Suwa
Suwa no mizuumi.	Crossed by a hare.

Busonshū 626

The designs of these trays are painted in black, orange, and green lacquer. Although red designs appear occasionally on black lacquered objects of the Kamakura and Muromachi periods, other colors were only added later, and most typically on provincial works.

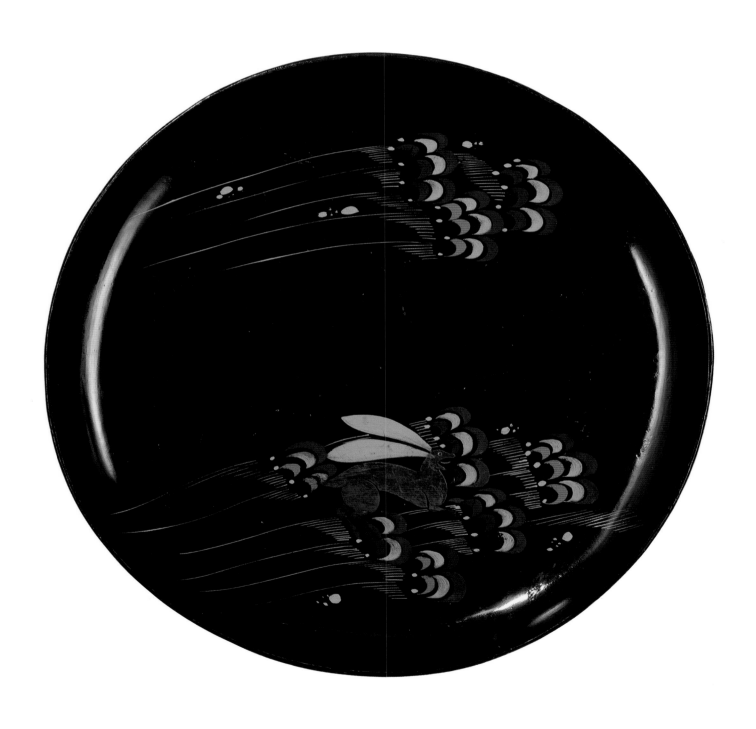

45.
DISH WITH WATERWHEEL DESIGN
Edo period, eighteenth century
Nabeshima ware, porcelain with underglaze blue and
celadon glaze
H. 7.8 × D. 30.4 cm.
Private Collection, Japan

Porcelain production in Japan dates from the early seventeenth century, when fine white kaolin clay was discovered near Arita in northwestern Kyushu. Emigre craftsmen imported techniques and designs from Korea and China, and so influenced the style of much Arita porcelain wares. Nabeshima porcelain was produced under the close supervision of Nabeshima clan members for its exclusive use or for presentation to other ruling families. It is of the finest quality, with designs drawn from contemporary textile patterns and shapes created to harmonize with lacquerware.

Examples in this catalogue (cat. nos. 45-48) are from a kiln established at Ōkawachi in 1675. Most wares from this site used imported cobalt blue in underglaze drawing with overglaze enamel decoration. This dish, however, is an exception. Five waterwheels are half submerged in alternate bands of celadon glaze and "blue sea wave" pattern. The wave pattern is created by a stencil technique known as *sumi hajiki* in which a preparation of ink was applied to the piece in areas to be left white. The entire surface was allowed to dry before the inked areas were peeled off leaving the desired blue lines. The waterwheel designs were transferred by tracing from drawings on paper.

The waterwheel motif, long associated with the Uji or Yodo Rivers (cat. no. 27), was a design favored by Nabeshima potters. In form, the high foot and curved body of this dish are typical of standardized sets of dishes for everyday use. This size is called a *shaku sara*, "one-foot dish." Occasionally on such large pieces a single waterwheel fills the entire round surface.

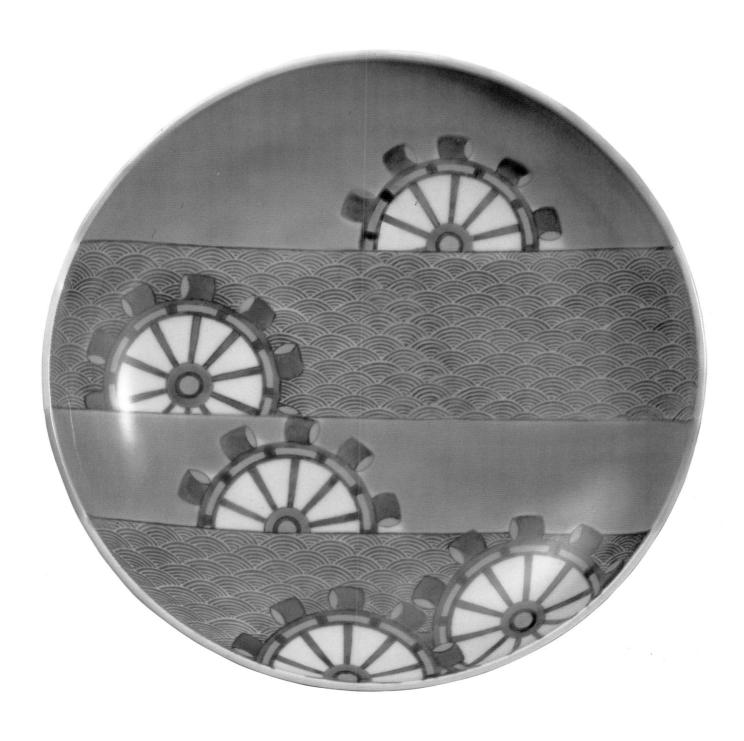

46.
DISH WITH FLOWER AND RAFT DESIGN
Edo Period, late seventeenth-early eighteenth centuries
Nabeshima ware, porcelain with underglaze blue and
overglaze enamel
H. 9. × D. 31.0 cm.
Private Collection, Japan

Cherry blossoms float beside small wooden rafts that have overturned in the briskly flowing water. The flower-raft design may be found in lacquer at the Kōdai-ji mausoleum (cat. no. 12) and in textile design (cat. no. 31). This small dish is of the so-called "seven-inch" (*nanasun*) size.

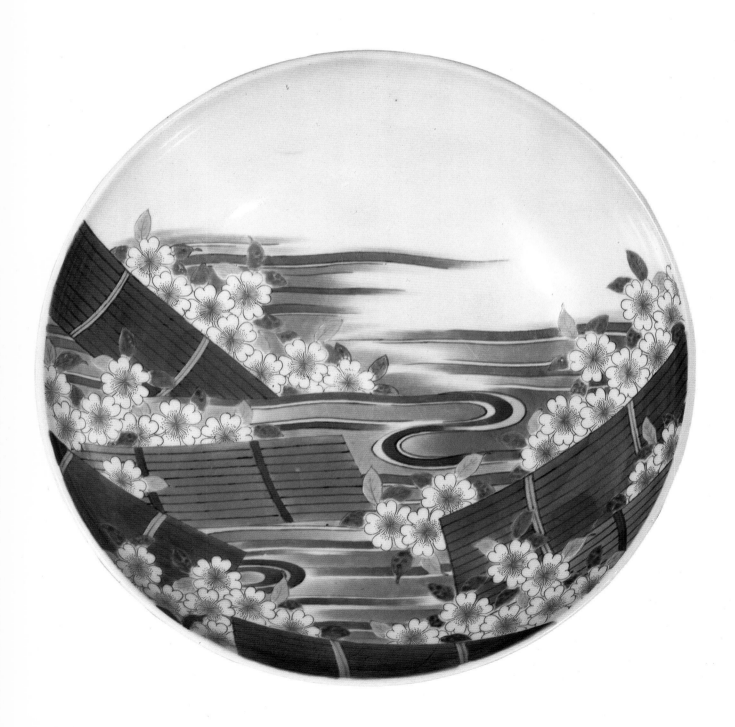

47.
WINE CUPS WITH DESIGN OF MAPLE LEAVES FLOATING ON A RIVER
Edo period, late seventeenth-early eighteenth centuries
Nabeshima ware, porcelain with underglaze blue and
overglaze enamel
H. 6.5 x D. 6.5 cm., each
Private Collection, Japan

These cups have as their decoration maple leaves floating on the Tatsuta River (cat. no. 39). This is a set of five cups for sake drinking, and may originally have had a matching decanter (*tokkuri*).

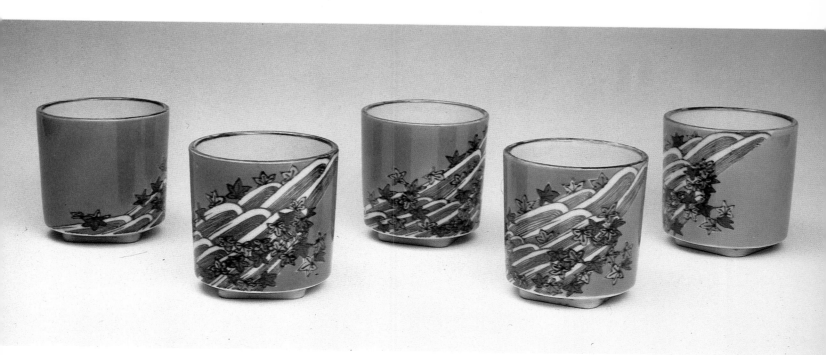

48.
DISH WITH DESIGN OF BUTTERFLIES AND WAVES
Meiji period, late nineteenth-early twentieth centuries
Iro-Nabeshima ware, porcelain with underglaze blue
and overglaze enamel
H. 9.7 × D. 32.3 cm.
Private Collection, Japan

This dish is a signed work by the tenth-generation Imaizumi Imaemon (1848-1927) working with the designs and techniques of the Nabeshima tradition.

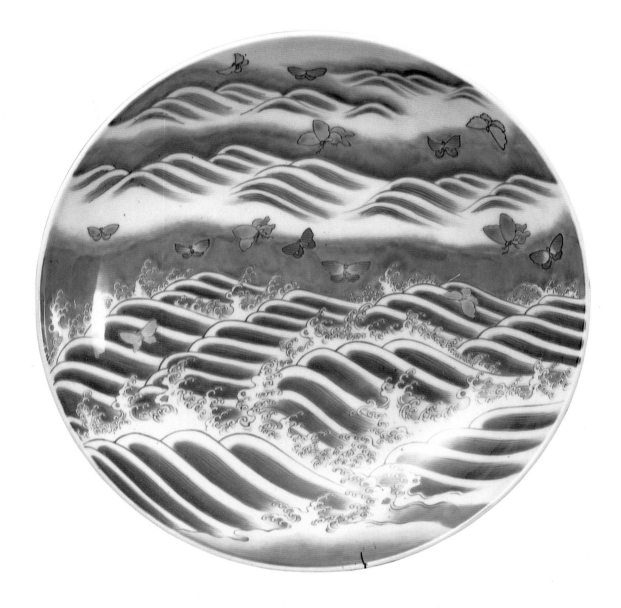

49.
DISH WITH DESIGN OF PINE AND WAVES
Edo period, nineteenth century
Ao Kutani ware, porcelain
D. 42.8 cm.
Suntory Museum of Art

Kutani porcelain in a wide variety of styles was produced in the southern part of Ishikawa Prefecture on the northern coast of the main island of Honshū. The making of Old Kutani (Ko Kutani) ware probably began in the 1650's, a few decades later than production at Arita. The first stage of manufacture lasted until the early eighteenth century. The designs of Old Kutani pieces show diverse influences from China, as well as motifs abstracted from nature, often rendered in yellow, green and purple glazes.

During the early nineteenth century, porcelain-making was revived near Kanazawa, and a great many kilns were built. In this dish, a revival of the Old Kutani greenware manner (*aode*), a grand pine tree shelters banana leaves against a background of "blue sea wave" pattern. The lines of the waves were drawn in black and covered completely with yellow glaze. The rim of the bowl, pine needles and banana leaves are all in deep green, the tree trunk in cobalt blue. While the style of the pine tree owes little to native design, the motif of a pine beach (*hamamatsu*) can be traced to *Man'yōshū* poetry and Heian painting. The combination of the long-lived pine and the fragile, unsightly banana plant is a curious juxtaposition of motifs.

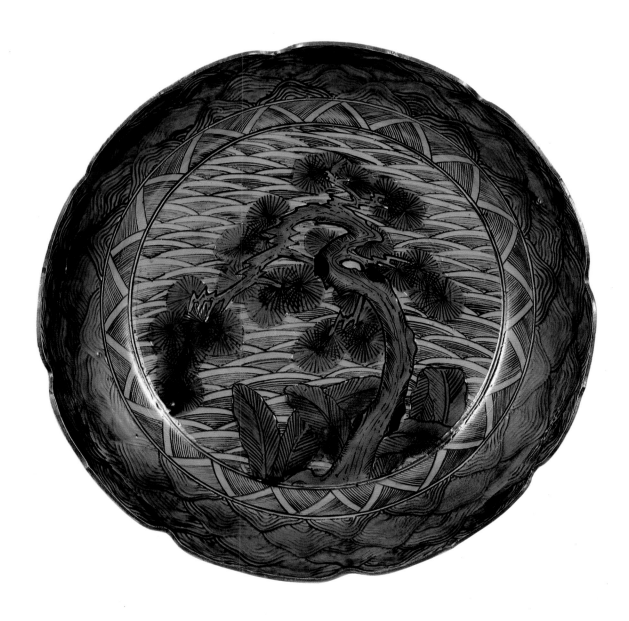

50.
DANCERS

Edo Period, seventeenth century
Six framed panels from a screen; colors and gold on paper
H. 80.0 × W. 48.0 cm., each
Suntory Museum of Art
Important Art Object

A solitary dancing figure of a woman occupies the center of each of these six panels that once made up a half-size screen. Their heavily colored robes and graceful poses with arms and fans outstretched present striking images against the background of solid gold-leaf. Other versions of this "Dancers" subject, in Japanese and American collections, suggest that it enjoyed some measure of popularity in the early years of the Edo period.

The focus of interest in these screens is the costumes and fans. Each dancer wears a *kosode* robe draped left over right and held together slightly below the waist by a narrow sash tied in back. The robes blouse over the tight sash, so that the opening edge folds over to reveal contrasting solid color lining. Gold-patterned undergarments are visible at neck and sleeve openings. Peeking out from the hems are feet encased in white socks, a clue that the dancers are performing inside, on a wooden or matted floor. Their graceful movements display the robes to greatest advantage, yet the figures retain a modest air.

The artist's careful attention to detail provides valuable evidence for seventeenth-century design. The robes combine geometric pattern, usually in the ground design or other well-defined areas, with bolder motifs of phoenixes in flight, dragons coiled in medallions, peacocks, birds in flight, and dragon-flies. A variety of techniques—metallic foil appliqué (*surihaku*) embroidery, woven figured ground, and tie-dyeing—are seen.

The features of the women themselves vary little from panel to panel. Their faces are pleasingly plump, with full cheeks and necks. Tiny pink mouths are slightly open; eyebrows are thin and high above long and narrow eyes. Very soft black hair is drawn back from the face to fall over the shoulders, leaving some tendrils. These lovely, anonymous dancers exhibit none of the frenzy that can be seen among dancers in contemporary genre paintings, nor are they the suggestive, haughty courtesans of the "floating world." Rather, they appear to be sedate members of the merchant class displaying their finery to greatest advantage.

The wearing of such elaborate robes of gorgeous colors, especially by merchant class wives, was to be a continual source of irritation to the Tokugawa rulers, who beginning in the mid-seventeenth century, passed a series of sumptuary laws against such luxurious display. The novelist Ihara Saikaku (1642-1693) wrote of current fashions in 1688:

> Fashions have changed from those of the past and have become increasingly ostentatious. In everything people have a liking for finery above their station. Women's clothes in particular go to extremes. Because they forget their proper place, extravagant women should be in fear of divine punishment. Even the robes of the awesome high-ranking families used to be of nothing finer than Kyoto *habutae*. Black clothing with five crests cannot be called inappropriate to anyone from daimyo down to commoner. But in recent years certain shrewd Kyoto people have started to lavish every manner of magnificence on men's and women's clothes and to put out design books in color. With modish fine-figured patterns, palace style hundred-color prints, and bled dapple tie-dye, they go the limit for unusual designs to suit any taste. (Shively, "Sumptuary Regulations and Status in Early Tokugawa Japan," pp. 124-125.)

The dancers on these panels seem to be advertisements for the very extravagances Saikaku described.

Several of the fans illustrate the themes of this catalogue: maple leaves in the flowing waters of Tatsuta River (cat. no. 39), pampas grass and wild carnations drawn in gold and silver pigment, and a red sun rising from the grasses of Musashi Plain (cat. no. 2). Fans were an essential accessory to dress, a point made beautifully here.